Eerie Legends

Eerie Legends

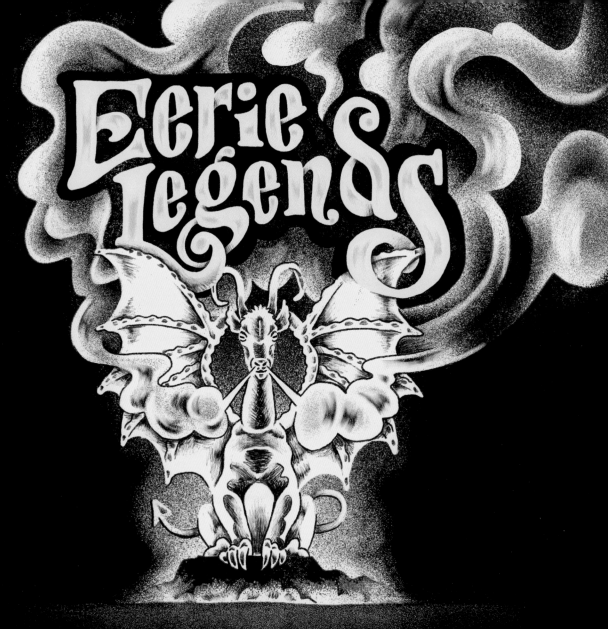

AN ILLUSTRATED EXPLORATION
OF **Creepy Creatures, the Paranormal,**
AND **Folklore** FROM AROUND THE WORLD

BY RICARDO DISEÑO
TEXT AND STORIES BY STEVE MOCKUS

CHRONICLE BOOKS
SAN FRANCISCO

Library of Congress Cataloging-in-Publication Data

Names: Diseño, Ricardo, author, illustrator. | Mockus, Steve, author.
Title: Eerie legends : an illustrated exploration of creepy creatures, the
 paranormal, and folklore from around the world / by Ricardo Diseño ;
 text & stories by Steve Mockus.
Description: San Francisco : Chronicle Books, [2024]
Identifiers: LCCN 2024009376 | ISBN 9781797229393 (hardcover ; alk. paper)
Subjects: LCSH: Folklore. | Tales--Cross-cultural studies.
Classification: LCC GR74 .D57 2024 | DDC 398/.4--dc23/eng/20240414
LC record available at https://lccn.loc.gov/2024009376

Manufactured in China.

Design by Neil Egan and Liz Li.

10 9 8 7 6 5 4 3 2 1

Chronicle books and gifts are available at special quantity discounts to
corporations, professional associations, literacy programs, and other
organizations. For details and discount information, please contact
our premiums department at corporatesales@chroniclebooks.com or at
1-800-759-0190.

Chronicle Books LLC
680 Second Street
San Francisco, California 94107
www.chroniclebooks.com

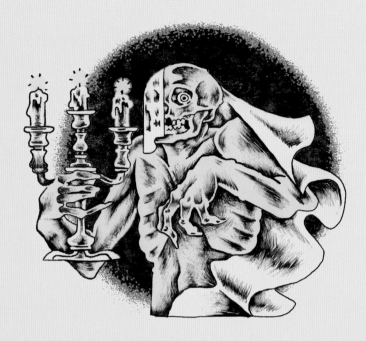

For Gabe, Adrian, Noah, Emma & Christian. Don't forget you are capable of anything. You are loved.

—R.D.

For Sandy, Ali, Alex, and Jake. And for Jody!

—S.M.

CONTENTS

INTRODUCTION

THESE CREATURES EXIST to the extent that we believe in them, or want to believe in them.

Why would we want to do that?

It's more colorful to believe in a world where they might exist. We can use them to tell stories about who or where or what we are, what we're afraid of, what we want. They can get to a truth that's not literal, describing uncanny possibilities that make sense to us alongside things that we think we know.

They can embody something terrifying, and by giving it an explanation and specificity, make it somehow easier to reckon with, or at least to comprehend. Sleep paralysis is a creature that sits on your chest after overindulgence. The plague comes for us in the form of a figure at your doorstep, wielding a rake or a broom. You don't want to see her at all, but if you do, hope she has the rake.

They are also useful warnings. It's one thing to caution kids against playing along bodies of water, but something else to ask them to imagine creatures rising out of the depths or stalking the shoreline, waiting to take them away. Okay, sure, you should be good so Santa will bring you presents. But if you're not, what

if you should expect a demon to stuff you in a sack and bundle you off to hell?

When vengeful, as in the case of La Lechuza and the pontianak, these creatures can act against terrible people in ways that might not be available to us as still-humans without supernatural agency. Our sympathies may also lie with the banshee, whose blood-curdling screams are actually an agony of empathetic mourning as she prepares a human soul for its passage into the afterlife.

They can also serve as symbols of regional and cultural pride. We can visit the Mothman Museum in Point Pleasant, West Virginia; admire his statue; and buy a hoodie. Swing by the Skunk Ape Research Headquarters off Highway 41 in southern Florida (they will also sell you a hoodie, or a set of skunk ape finger feet). Take in a hockey game played by the New Jersey Devils and take home a jersey with a devil-horn-and-tail logo. El chupacabra: fearsome livestock menace, and a pop culture symbol of the outsider quality foisted on Puerto Rican citizens of the United States. (T-shirts also available.)

But mainly: Scary stories are fun. There's the catharsis of facing fears; the what-if electricity of imagining something menacing, malevolent, or weird from a safe(?) distance; and storytelling opportunities to share in collective folklore. It's what's kept some of these creatures and their tales alive for centuries, and what conjures new residents of our strangely haunted spaces. [Loab has entered the chat.]

Banshee

The group of soldiers is warming themselves around a fire within the safety of the tree line when they hear the skull-shaking wail. Its tone rises, doubling, tripling in volume. Their bodies curl inward, sound waves pressing the air in around them, their gloved hands no protection for their ears. It's her. In chaos they disperse into the forest, trying to distance themselves from their fate in tomorrow's battle, and from each other, each one tainted by hearing the sound of death, either forewarned or foretold. They will discover which soon enough.

———

THE BANSHEE IS OFTEN MISUNDERSTOOD. Her hallmark is a terrifying screaming, shrieking, and wailing, but her intent is to help

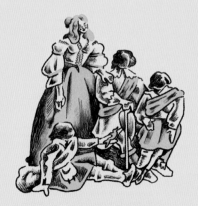

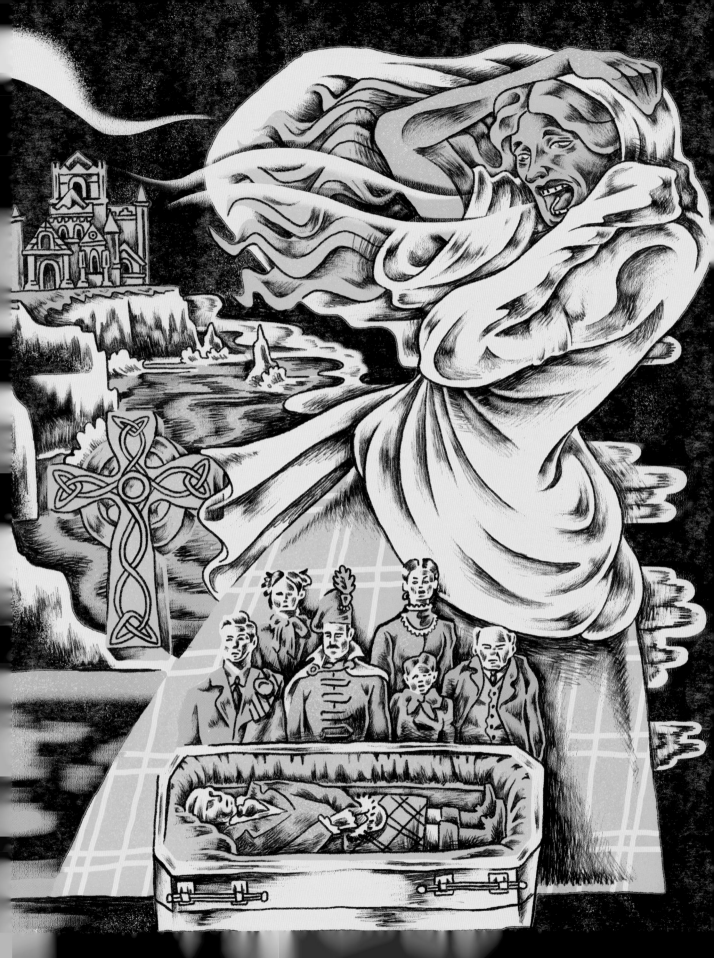

those who hear her prepare for an imminent death—not to bring about that death.

In some folktales she is a free-roaming harbinger of doom, but in her most classic iteration the banshee is an ancestral spirit closely associated with a specific, landed Celtic family. In her life either she had transgressed or been dealt a terrible fate, and ever after she appears to members of her family clan when their deaths approach. Her purpose is to prepare them, and help their spirits pass from this world into the next—just as hers for now cannot. Sometimes she appears to the person who is about to die. Sometimes she appears to other family members to warn of the impending death of a relative. It's said she will stay in this role as long as any of the family retain their ancestral land.

In appearance she's either old or young, with long hair that is either red or gray. Her eyes are bloodshot from her agonized cries.

She is the ghostly manifestation of the keening or wailing woman, a figure who plays an important role in traditional Irish religious and cultural rites around death. These women would give voice to and physically manifest grief for families when a loved one passed away, also with the goal of helping the spirit transition. Their fee would generally put their services beyond the reach of any but the wealthy, and their death-related spiritual power and otherness also feed into aspects of banshee mythology.

S he knew it was time before she saw the specter floating outside the window. Before the screaming.

Hello, Emma. You're welcome in, always.

She knows the figure from the painting, which has hung in the main hall for hundreds of years. In the portrait, Emma stands elegantly beside her husband, who sits in a chair. Their two boys are in front of them, playing with a taxidermic bird while the family hound looks up at her husband. All long dead.

Hovering at the bedside now, Emma's face is raw as her throat-shredding scream gives voice to the chemotherapy and radiation that has left the woman in the bed feeling burned and hollowed. The time the treatment had bought her is now at an end.

She wonders if this is how Emma appeared to her parents, grandparents, and great-grandparents when they passed. She remembers her grandmother setting a place for Emma at dinner, in the last days when she felt she'd had enough. She remembers as a child seeing the wide-eyed horror of her uncle in his last moment, his skepticism overturned by shock and fear.

She calls her daughter in New York.

Do you see her?

I do.

Is there time for me to fly in? I can get—

I don't think so.

I love you.

Once her daughter has sold the estate, she wonders if Emma will be freed of this place with none of them left on the land. How she must suffer, feeling these deaths. Her eyes are wet, blood-rimmed, empathetic, pleading. Miserable.

We can rest now, she says to Emma, closing her eyes. As her awareness recedes, she hears the screams as a lullaby.

BETTY AND BARNEY HILL ABDUCTION

I told Betty to look out—and the object was still around us. I could feel it around us. . . . When I got in the car, it had swung around and so it was out there. I—I know it was out there. Yeah, it's out there. But I don't know where. . . . Ohhh, those eyes! They're in my brain! Please can't I wake up?

———

THE ABDUCTION STORY OF BETTY AND BARNEY HILL—perhaps the most famous of its kind—begins on the night of September 19, 1961, as the couple are driving home after spending their honeymoon at Niagara Falls and in Montreal. They notice a strangely moving, multicolored light in the sky that seems to be following them. They stop and get out of the car several times to have a better look. Betty sees a row of windows along the side of the glowing pancake shape. Through a pair of binoculars, Barney sees

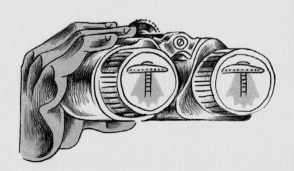

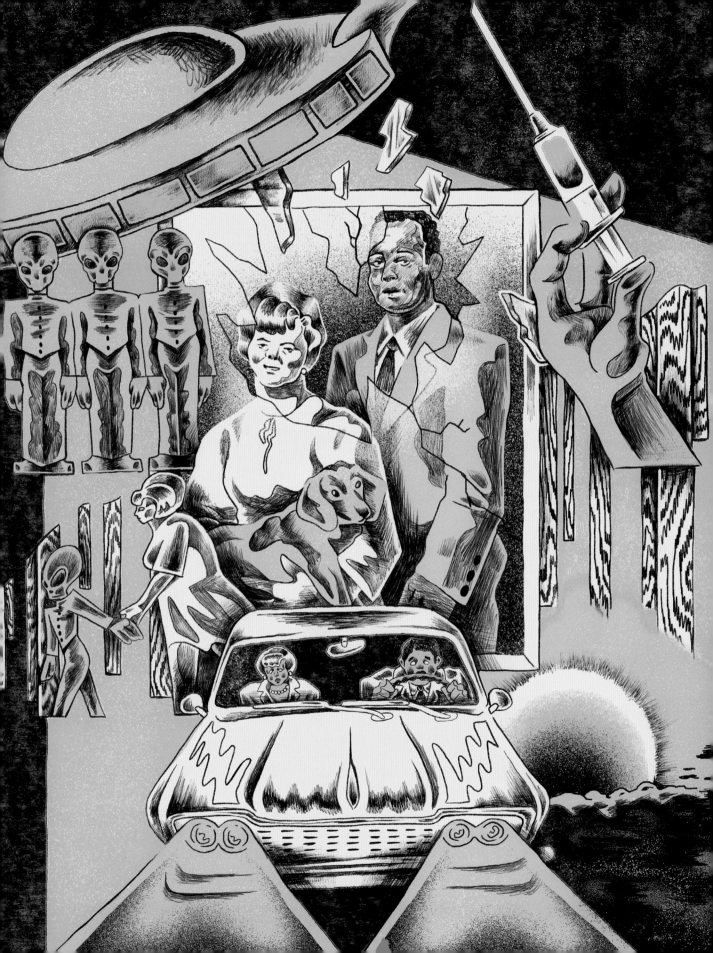

figures moving within, and a ladder or ramp descending from the object. Alarmed, they hurry to get back into the car, only to hear an ominous electronic beeping sound coming from behind them.

When they emerge from a mental haze, they find they have driven about 35 miles south of the site of their encounter. When they finally arrive home, they discover they've inexplicably lost about two hours of time. They feel clammy, and have strange sore spots on their bodies. There is mysterious wear on some of their clothes. Their watches have stopped. There are magnetized circular marks on the trunk of their car.

Though they are unsure of what happened and worry about publicly sharing this strange encounter, they do describe it to Betty's sister. They then privately report it to the air force, as well as to a member of the National Investigations Committee on Aerial Phenomena, who finds their story credible.

Later, under hypnosis, they recover lost details. They recall being taken inside the ship by humanoid aliens with gray skin and wide black eyes. They are asked to partially undress and are examined. The aliens are friendly, speak English telepathically, and even joke around, although there is a scary moment with a needle. The visitors stress that they mean no harm.

It's only when an intrepid news reporter learns details of the case and publishes an article titled "UFO Chiller: Did THEY Seize Couple?" that their story becomes an international sensation, making them the first people to report an abduction, and establishing "the grays" as the most frequently encountered alien type.

The light is tracking him. There's no question about it now. Every time he looks up it's a little closer, a little brighter.

It's late, and he notices now that he's not too far from where Betty and Barney had their strange encounter. They'd confided in him after church. His father served in the air force, and they wanted to know if his father had ever mentioned anything similar. He could tell that when he said no, they'd been hoping for a different answer.

Not really because he wants to, but because he feels it's a thing he must do, he pulls the car off the highway. As he drives down a dirt road, he can see a glow through the trees ahead, the light having settled into a clearing. The short men lead him up the ramp and inside the disc-shaped, many-windowed craft. Betty and Barney had not described the inside of the ship, and he hadn't thought to ask—there was so much to wonder at otherwise. He sees now that the primary material of the ship—the floors, the walls, and the doors—glows with an inner light. He's led to a room with a central table.

Asking aloud if he should undress, he hears that he should, *Please*.

Asking, so you speak English?, he hears, *We are not speaking English*.

He wonders about the uniforms, which seem nearly recognizable, Earthly. Worn for his benefit?

The table is neither warm nor cold. It has deep grooves and perforations. He's trying to fix details to memory. He'll be able to confirm the Hills' account.

Will this hurt? He tries just thinking this.

Black almond eyes look into his. *I'm afraid it might.* A gray hand lifts a long blade.

His eyes widen as the other gray hand of the surgeon passes over his face and stills his muscles. He thinks a neuron-flash of words: *no wait no hurt no*.

Yes, he hears. *That was Phase One.*

The blade gleams.

This is Phase Two.

CATACOMBS OF PARIS

The bones of six million souls lie beneath the streets of Paris. Relocated from horrifically unsanitary overcrowded cemeteries, the remains were transferred in the Napoleonic era to a vast underground ossuary, where they lie silently, but perhaps unquiet. It's said that if you roam the labyrinthine tunnels at night, the voices of the dead may persuade you to wander ever deeper, to die lost below, and to leave your bones to join the others.

———

CREATED TO SOLVE A PUBLIC HEALTH CRISIS, the Catacombs of Paris were envisioned from the beginning with an air of theatricality. Only one of its two hundred square miles is open to the public, but that portion is marked by aesthetically arranged towers of

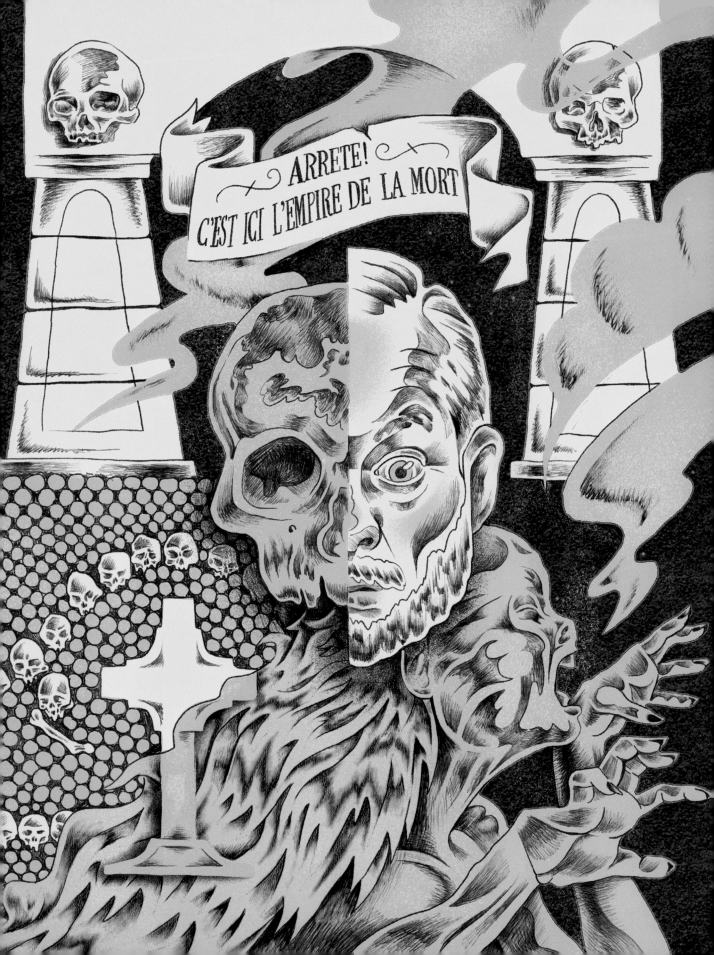

skulls and femurs, quotes and poems about death, sculptures of buildings carved into the limestone walls by a quarry worker, and the phrase "*Arrete! C'est ici l'empire de la mort*" ("Stop! Here lies the empire of death") chiseled over the entrance.

Among the legends of death and disappearance in the catacombs, there's at least one very real instance documented and memorialized. A worker at a nearby hospital, Philibert Apsairt, went missing after he entered and wandered the ossuary in 1793 while it was still under construction. His body was discovered eleven years later in 1804. His remains have been preserved in a tomb where they were found, in an off-limits gallery.

Another tale involves the early 1990s discovery of an abandoned video camera, found by a group of cataphiles exploring restricted areas. The video (easily findable online) shows a man recording in the forbidden tunnels, encountering weird noises, freaking out, and dropping the camera. Did he die down there, never to be found? Was the clip created to air on a TV show about scary places? *We may never know.*

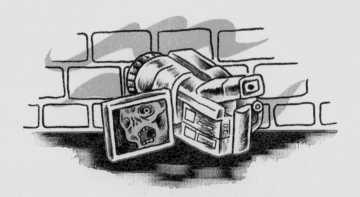

It is unfortunate that he didn't read the sign posted near the entrance. By the time he sees the second sign (*attention, ne touchez pas les os*), he is already holding a skull in one hand and a femur in the other. His French is bad. In fact, it will never get any better. But the skull and crossbones graphic on the sign makes his transgression clear.

The skull in his hand is light, surprisingly light. He's heard about the lightness of bones and their strength, but it is another thing to understand this by touch. The bones are covered with a fine grit. Dust. Something else.

When is he going to have another chance to hold a skull in his hand? Hopefully never. After tossing it up and catching it, he puts it back on one of the bone piles, sorted by type.

Even without eyes, the skull seems to be looking at him. He can feel all the skulls looking at him.

How strong is this femur? Could he crack it? He looks around. With his hands on the far ends of the shaft he strains to snap it, but nothing. Again, but nothing. All-in now, he crouches and brings the middle of the femur down on one upraised knee as hard as he can. *Crack.* It's in two.

At first, he thinks he is hearing an echo. From around the darkened bend, the bone-on-bone sounds continue, aggregating, growing louder. As the bone-thing comes at him from around the corner, he has just enough time to wonder what is holding it together before it is upon him. Now he will learn how much force it takes to snap his own bones.

EL CHUPACABRA

They prowl on two legs, or four. Their skin is leathery, or scaled, with patches of fur, or quills. They may have bat-like wings. Their eyes are red or black, with a paralyzing gaze. Always with razor-sharp fangs and claws. And they crave fresh blood: from goats, sheep, pigs, chickens, cows. You.

———

OUR TALE BEGINS IN THE PUERTO RICAN VILLAGE of Moca in February 1975. Over the next several months, dozens of farm animals are found dead, seemingly drained of blood, punctured and clawed. Early theories include the weird work of a Satanic cult, or space aliens lured to Puerto Rico after the construction of the giant Arecibo telescope. An explanation arrives in the form of a creature that a local man claims to have fought off, and which shares

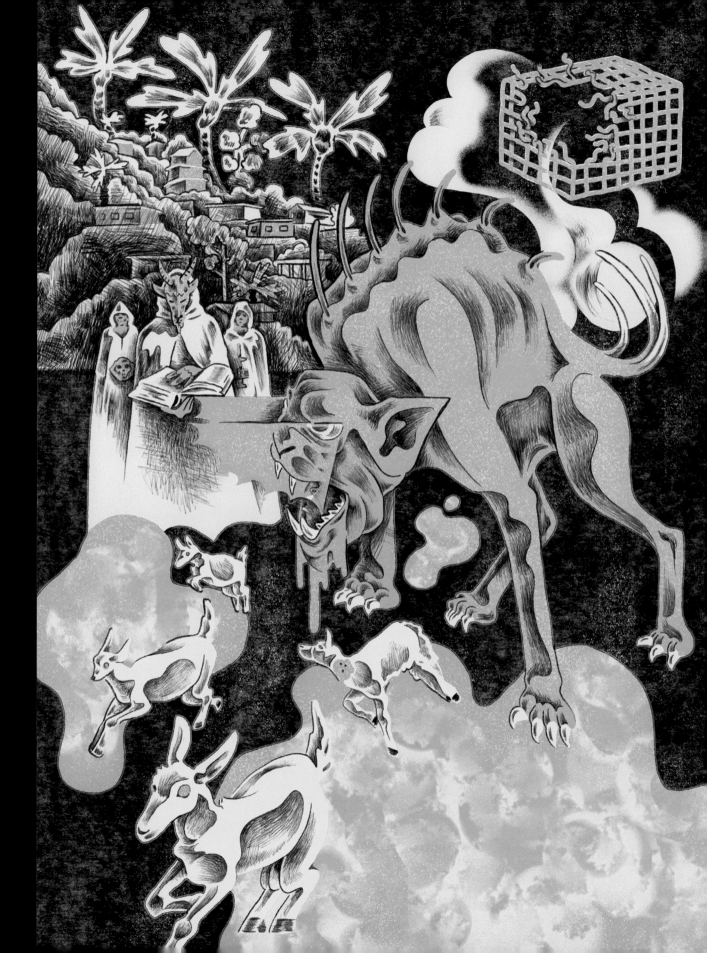

some of the features that will feed later chupacabra descriptions, including creepy wings, claws, and fangs. The creature is dubbed El Vampiro del Moco.

We pick up in 1995, in the Puerto Rican town of Canóvanas, where something is killing farm animals and pets in a Vampírico fashion. This time, an eyewitness account provides an extremely detailed description of the bloodthirsty monster. So specific that author Benjamin Radford (*Tracking the Chupacabra*) is able to match it to the creature Sil in the movie *Species*, released just months earlier. Designed by the Swiss artist H. R. Giger, Sil is certainly a creature that haunts the imagination.

But *something* is killing the town's animals, and it becomes a story of international fascination (it's now that comedian Silverio Pérez is credited with coining the term *chupacabra*). Sightings spread throughout Central and South America, Mexico, and the southern United States. Some "chupacabra bodies" are even discovered, but they turn out to be dogs or coyotes disfigured by mange.

There have been no reports of human deaths attributed to the chupacabra. Yet.

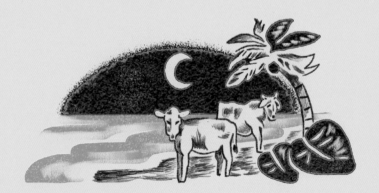

I can smell them. The smell is on my tongue. They are afraid. They scream when they smell me.

They know my smell from when I feed. I open them up. The screaming will bring the animals with the boom sticks.

There are other animals here. Many kinds. Not as good as these.

The place they are inside does not keep me out.

The weak are easy to catch. They are not as good. The big ones protect the small ones. The big ones are good.

This is a good one. I look in its eyes. It is now very still.

My teeth are inside it. I drink fast.

The big ones make me full. I can hide. Sleep.

When I am very hungry I use claws. Take the insides out.

There is some left to drink inside it.

Fast.

Now I go. Hide. Sleep.

Think in sleep of eating more.

Enfield Poltergeist

This has to stop. The crashes upstairs. The knocking on the walls. In the walls. In the ceiling. Furniture wrenched out of place. Drawers pulled. Beds rattling. Vic hearing it too, up in the bedroom, frightening him. Big guy, Vic. The girls are terrified. What are we to do, then? Call the police?

———

ON SEPTEMBER 1, 1977, at approximately 1:00 a.m., Constable Carolyn Heeps and another officer responded to a call of strange occurrences at 284 Green Street in London's working-class neighborhood of Enfield. In the home were single mother Peggy, her daughters, Janet (eleven) and Margaret (twelve), and their two younger brothers, who are not prominent in most accounts. Constable Heeps reported that she heard knocking in the walls,

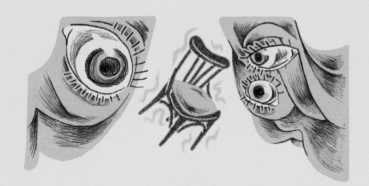

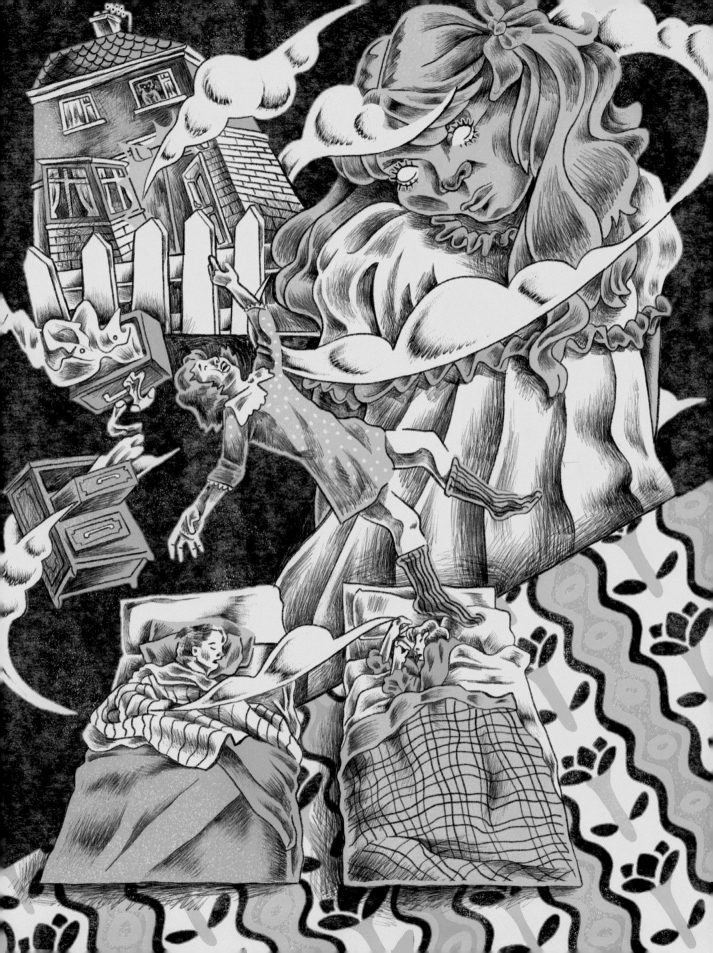

and after the living room lights switched off, she saw a chair slide approximately four feet across the floor by no visible means.

The family enlisted the help of other witnesses, including reporters. A local photographer sent by the *Daily Mirror* spent significant time with the family and produced images that include Janet seemingly gripped in a trance and levitating above her bed.

Further manifestations include items being flung about and heavy furniture moving on its own, including a hefty iron bed frame. Janet begins to manifest the spirit of former tenant Bill Wilkins, who seems to speak through her in a low, creepy voice.

Intense media attention follows. Paranormal investigators and skeptics alike arrive and experience these phenomena with varying degrees of credulity. Nothing spooky happens when there is active filming, and seldom happens when Janet in particular is not around. A magician and a ventriloquist offer debunking theories. A few years later, the girls admit to faking some instances, saying, "Oh yeah, once or twice . . . just to see if Mr. Grosse and Mr. Playfair would catch us. They always did." Grosse and Playfair, of the Society for Psychical Research, voice their own occasional doubts, but hold that the vast majority of the paranormal activity is real. Reports of the events peter out by 1979, but fascination in the case endures.

In 2011, a reporter for the *Daily Mail* visits Janet and asks again how much of the phenomena was misdirection. Janet replies, "I'd say 2 percent."

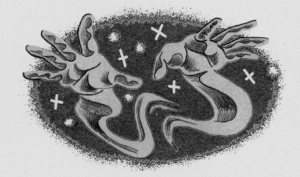

W ho or what is behind all this? It's the question everyone is asking. Asking her, asking her sister, her mother. Asking out loud, in empty rooms, in voices raised to the house, to its spirits. *Who are you? What do you want?*

There are a number of possible names. She feels the answer could be Bill Wilkins. That feels right.

They are gathered around the recorder and the questions begin. When the Voice comes from her, it is low and raspy. Anyone watching her would not see signs of her speaking normally. The Voice feels conjured through her.

JUST BEFORE I DIED, I WENT BLIND, AND THEN I HAD AN 'AEMORRHAGE AND I FELL ASLEEP AND I DIED IN THE CHAIR IN THE CORNER DOWNSTAIRS.

I breathe. I see. I see light. She thinks this. These thoughts are sharing space with her own, overlapping hers.

We are in my space. You are in my space. You are my space.

She hears the investigator ask the Voice why they can't see him.

Because. Because.

I'M INVISIBLE . . . BECAUSE I'M A G.H.O.S.T.

Why had she said it that way? Spelled it out?

Don't be afraid. This will be fun.

Flying Dutchman

It can never reach port. The ship's crew of dead men, doomed by the recklessness of their captain, must sail on forever, without the hope of peace or the comfort of landfall. They roam the Seven Seas, even in death still under their terrible captain's command, their purpose only to suffer. So powerful is the curse upon them that anyone who beholds the ghastly, glowing ship will find their own fate sealed.

——————

By some accounts, the *Flying Dutchman* is a ship whose pirate crew has been cursed for their dreadful crimes. They must sail on after death until they have done penance for their evil deeds.

More commonly, it is a Dutch trading vessel that sailed in the mid-1600s and whose crew was doomed by the acts of the ship's

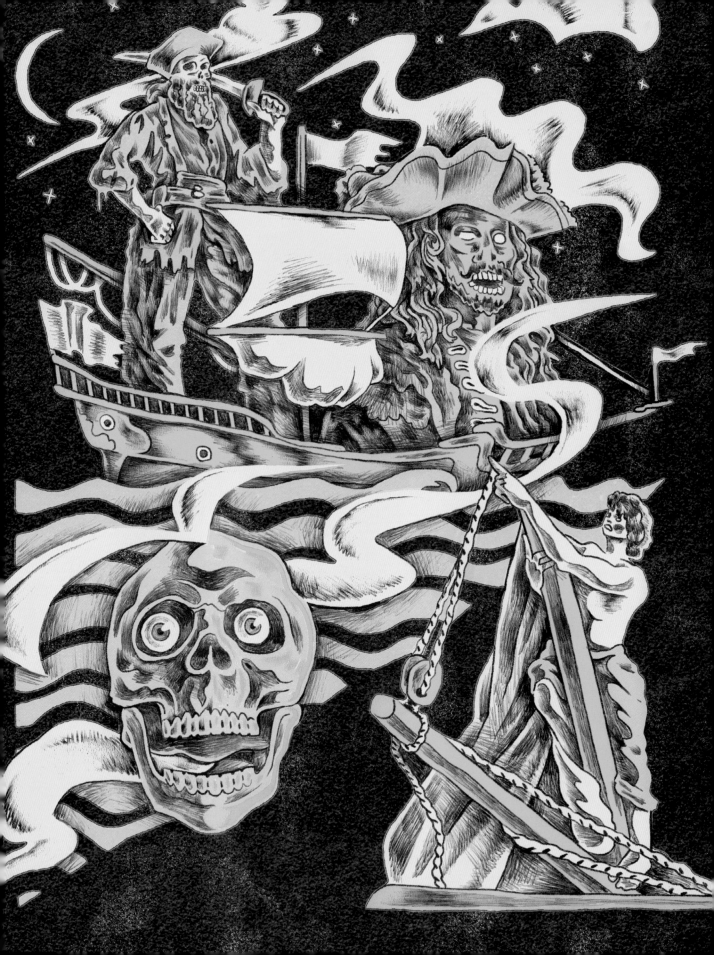

captain, Hendrick van der Decken. (It is either the captain or the ship itself that was called the *Dutchman*.)

In that legend, the ship is returning to Amsterdam with a hull full of spices and other goods from the East Indies, and it follows a common sailing route around the Cape of Good Hope at the southern tip of Africa. Rounding the cape, the ship is beset by a terrible storm, and turbulent seas threaten to capsize it and pitch the crew into their watery graves. Van der Decken's crew pleads for the captain to turn back, or put up to port, but he refuses. The crew rebels, and van der Decken kills the main mutineer, throwing his body overboard. At this point the captain hears the voice of the ship itself—or some other power speaking through it—asking him if he will sail to port or press onward. He vows to keep on "until the day of judgment." The ship goes down, and the dead captain and crew sail forever after on their cursed, spectral craft.

Bad luck or death is said to follow sightings of the ghost ship. If anyone is foolish enough to hail the *Flying Dutchman* at sea, the haunted crew will send over a smaller craft and plead with the living to pass on letters they have written to their loved ones (all of course long since dead). But contact with the cursed crew is forbidden, so anyone taking the letters in assistance brings death upon themself.

The ship appears to us engulfed in blue flame—or this is what we think at first. Its appearance is sudden. There is nothing, and then there is a flash in the dark. What burns blue? Oils? Silks?

The ship is not so far. Through a glass, we can see it is not aflame, but aglow. What glows pale blue? Plankton? How, then, is it stuck to the ship, and crew?

They've already dropped a boat, and its crew is rowing toward us in some haste. It is not a good night to be crossing the great waves in such a craft. But their approach is swift. Everything is happening quickly.

Come close, we see that the boat is rotten. It is in no way seaworthy, no longer even a boat.

The crew is also rotten. In their faces we see some horrible pestilence. Noses and teeth rotted away, skin withered tight, eyes invisible in their sockets. Their bodies wrong-shaped and thin under rags.

One calls in a rasping, salt-scratched voice. *Please. For our families. Please.*

In a claw hand he holds a satchel.

We have been away so long. Please, for our families.

Why do they not ask for medicines, for food?

We lower a roped bucket for him to place the satchel. With the bucket and its contents hoisted back up to deck and in our hands, we see the small boat is now gone, as is the craft from which it came.

We open the satchel. It is full of sodden paper pulp. We cast it overboard. But the die has also been cast. As our own ship goes down, some days later, we know there will be no letters for our own families. We are gone without a trace.

Headless Horseman

The rider and horse rear back in silhouette against the night sky. His head rests on the pommel of his saddle, grinning like a jack-o'-lantern. The horse carries the rider toward you with unnatural speed. Your own horse is no match. Your one chance, more impossible by the sound of each approaching hoofbeat, is to make it to the wooden bridge, across which he will not go.

———

The HEADLESS HORSEMAN who haunts New York State's lower Hudson River Valley first appears in American writer Washington Irving's story "The Legend of Sleepy Hollow," published in 1820. Sleepy Hollow is a fictional glen set near the real village of Tarrytown, which Irving visited for a while in his youth. Inspired by the legends, ghost stories, and Native American folktales that

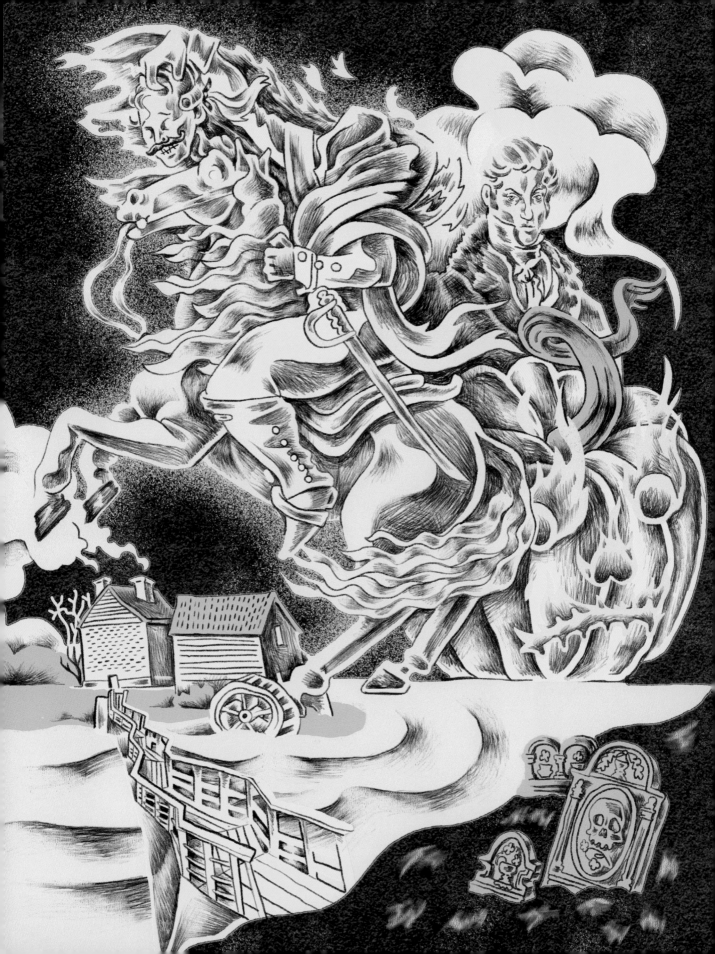

he heard there, Irving made Sleepy Hollow explicitly "bewitched" by this energy, its residents dreamily believing in stories of haunting figures and supernatural activity. Foremost of these is the tale of a Hessian cavalryman who was decapitated by a cannonball and rides in the night searching for his lost head.

The short story primarily focuses on the hapless schoolteacher Ichabod Crane, who loves a wealthy farmer's daughter named Katrina Van Tassel, but faces a "broad-shouldered and double-jointed" romantic rival whose nickname is Brom Bones.

At a party, the guests regale each other lightheartedly with stories of ghostly specters they've seen or heard in the night. Talk turns to the horseman, and Brom says he once challenged the ghost to a race, and was winning before they came to a church bridge and the horseman disappeared in a flash of fire.

On his lonely ride home, Ichabod sees the horseman, who gallops toward him. Ichabod makes it across the bridge, but the horseman doesn't disappear, and instead hurls his head at Ichabod, knocking him from his horse. The villagers never see Ichabod again, but a smashed pumpkin is found where the encounter took place, leading to speculation that Ichabod fled Sleepy Hollow in terror, and the horseman was actually his rival, Brom.

Intriguingly, a memoir published in 1798 by Major General William Heath describes a Hessian artillery man whose head is taken off by an American cannonball in the Battle of White Plains, which happened about eight miles from Tarrytown.

We're out of gas.

What do you mean we're out of gas? We're out of gas?

He has a gas can in the car. He needs it often enough. They push the car onto the shoulder, leave the flashers on, take the can, and start hoofing it into town. It'll be a couple miles at least. Long enough for Dave to get really wound up.

Why do you keep doing this? Why do I keep letting you do this to me? I— Is that a dude on a horse?

They see a rider mounted at some distance in the light of the moon.

Yeah. Okay weird. What is it, like midnight? Just out riding around?

No, he's probably out trying to scare people. Like when our school bus driver hired someone to come riding out of the woods and scare us all on Halloween? That was awesome.

This doesn't seem awesome. This seems bad. Does he see us? He must see us.

The horse begins to gallop.

It can't be. He says this. But he thinks it probably is.

Doesn't matter. Angry guy on a horse coming our way.

They run. Fear keeps them on the road instead of ducking into the trees. This isn't going to work. Hooves beat closer. If it wants a head, let it take Dave's. He shoulder-checks him, and Dave goes down with a *woof.*

The rider disapproves. Closing his distance to the runner, his blade flashes as he pulls it from his scabbard.

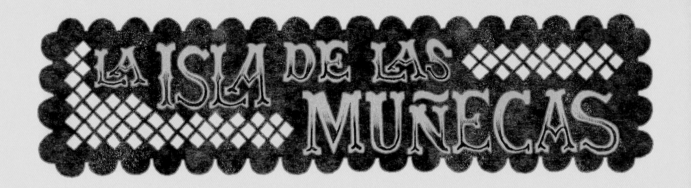

LA ISLA DE LAS MUÑECAS

Intact, headless, limbless, or just the head alone, they are strung suspended in the trees and along fences. They hang from the ceilings of buildings, and are tacked to the walls inside and out. Antic, begrimed, and rotting, they are the work of one man, who over fifty years gathered them for his own private, macabre display.

———

THE ISLAND OF THE DOLLS is a human-made island amid the Xochimilco canals south of Mexico City. It was originally built up for agricultural purposes, and as the story goes, in the early 1950s, the island's caretaker and sole inhabitant, Don Julian Santana Barrera, found the body of a young girl who had drowned in the canals under mysterious circumstances. Sometime later, he

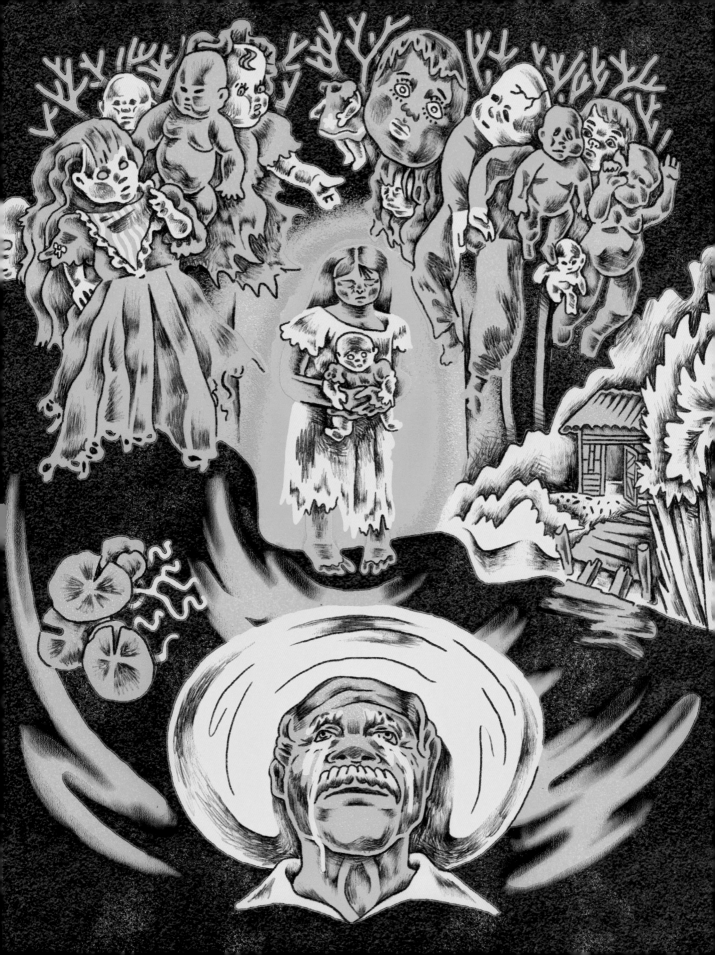

found a doll floating nearby. Believing it had belonged to the little girl, he hung it in a tree on the island in respect for her spirit, and also perhaps to ward off spirits of evil intention.

This tribute was the first of what will become hundreds of dolls that he will display on the island over the course of the next fifty years. Some dolls are gifts, while the others are scavenged or traded for with produce grown on the island. He collected dolls and doll parts of all kinds, their condition unimportant, believing they were possessed by the spirits of other dead girls. Though some dismiss this idea as one man's superstition and obsession, others say that at night, the dolls move and whisper, their eyes glowing, seemingly animated by some soul.

In 2001, at age eighty, while Don Julian was out fishing with a nephew, he claimed that a mermaid had been singing to him, seeking to take him away. The nephew warned his uncle to be careful, and went to milk their cows. When he returned, he found Don Julian had drowned in the same place that he had said he'd found the girl.

While Don Julian's family does not believe there ever was a drowned girl found in the canals—there has never been any evidence or a body to support the story—the island remains a testament to Don Julian's belief. After his death, his family opened the space to tourists, letting the world see the display that the hermit caretaker had intended only for himself, and for the spirits.

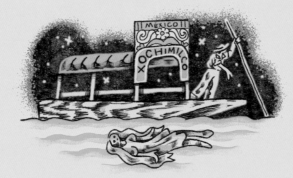

She knows on her first visit, even before stepping off the ferry onto the island's wooden dock, that she will be back. That she'll stay, and hide. That she'll talk to the dolls.

Seeing them tied to the trees, whole, in parts and pieces, with a history of weather, decay, and tragedy written on their faces and limbs, she feels them clearly as souls. She feels them as she imagines the man who gathered and lived with them on the island must have felt them. What did they say to him? What would they say to her?

On this trip she peels off from the group as soon as she is able, hiding in a spot she'd picked out on her first visit. It's difficult not to go straight to the dolls now, but they will only speak at night. She waits. Experimentally, she thinks a greeting and directs it to the chewed looking doll wired onto the side of the main building, but receives no reply.

It takes forever for the last tourist boat to leave the island. Cold, sore from inactivity, electric with adrenaline, she approaches a spiderwebbed baby she feels a connection to—something about the rotting clothes reminds her of a childhood doll of her own. Aloud, she offers a greeting, introduces herself, strokes the flaking plastic of the doll's cheek. Nothing.

Then, a whisper. Whispers from the trees. From the dolls in the trees. From a distance.

She walks to them and puts her ear up to a charred doll's head, then to another, relatively clean, and another. They are whispering, but she can't make out what they are saying. Whispering to each other, not to her.

The call that does come for her comes from the water. It is something between words and music, and hearing it, she feels warm, soothed. A calm she has never felt, a peace she has always wanted. From this song, she knows the water will warm her more. Wading in, she feels the song, not the cold. Deeper. Not cold. She will find the singer, singing this song for her, and her alone.

41

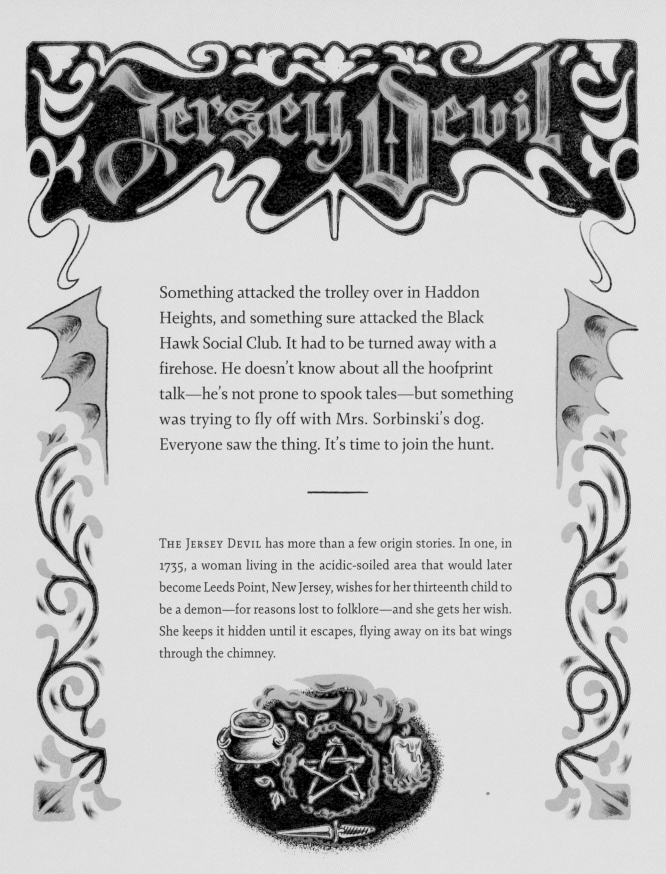

Jersey Devil

Something attacked the trolley over in Haddon Heights, and something sure attacked the Black Hawk Social Club. It had to be turned away with a firehose. He doesn't know about all the hoofprint talk—he's not prone to spook tales—but something was trying to fly off with Mrs. Sorbinski's dog. Everyone saw the thing. It's time to join the hunt.

———

THE JERSEY DEVIL has more than a few origin stories. In one, in 1735, a woman living in the acidic-soiled area that would later become Leeds Point, New Jersey, wishes for her thirteenth child to be a demon—for reasons lost to folklore—and she gets her wish. She keeps it hidden until it escapes, flying away on its bat wings through the chimney.

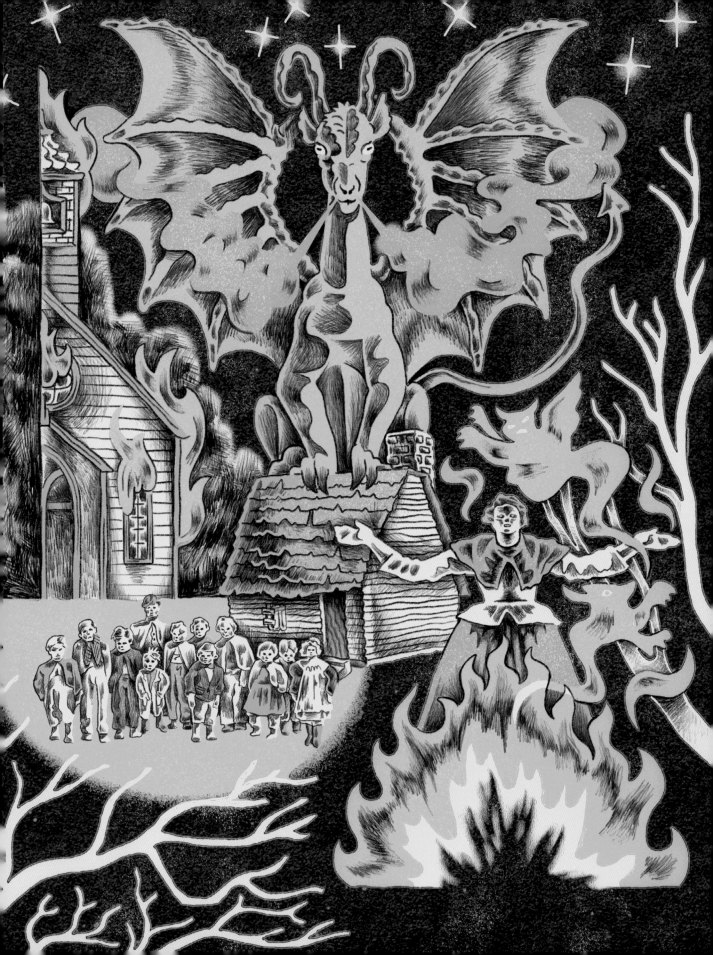

In another, a woman named Leeds finds her thirteenth baby cursed—or maybe she cursed it herself, dabbling as she did in witchcraft, with a husband who practiced astrology. At first the baby seems human, but it quickly transforms: Its head stretches into that of a goat, and it sprouts leathery wings, a devilish tail, and hooves. It grows to six feet tall, screams, and flies out through the chimney. In some tales it also eats the midwife.

There are later sightings of the devil. In the early 1800s, a prominent American naval officer claimed he hit something like it with a cannonball while testing armaments, and that the creature flew away, unaffected. Even Joseph Bonaparte, brother of Napoleon, who lived in the area, claimed to have a run-in with the creature while he was out hunting on his estate. He was following strange tracks when he encountered a hissing, bat-winged, horse-faced creature, which flew away before he could blast it. Around the same time, farmers attributed mysteriously slaughtered livestock to the devil and said they could hear it screaming from the woods.

For a week in mid-January 1909, there was a wave of frightening encounters with the devil reported by people around southern New Jersey and into bordering areas. Media reports include a winged monster attacking a trolley car and a social club, a postmaster seeing it glowing in the dark and hearing it screaming, and police officers shooting at it with no effect. There are weird hoofprints in the snow. The devil is spotted on rooftops. Panic spreads. Schools close. A hunting party forms. The encounters taper off, but the legend persists.

This is not a community for devilishness or blasphemy. The planets do not guide the souls of men. This cannot be conceived, let alone spoken of or written. The husband knows what this evil he spreads can invite. God only knows what she gets up to. There are findings of strange bones and seed pods among the ashes behind their home.

Those who regard them askance find their crops waning, their animals ill, and themselves or their children beset by fever. These cannot be coincidence.

Since she has been heavy again with child, there has been dark speculation about its origin. That she hasn't been seen for months causes more. It is said that she has given birth, and they have eaten the baby. Or that the birth creature has consumed her.

Their children will not speak of the pregnancy. It is as though by some means they are prevented from doing so.

The day arrives without warning, but also with the feeling of a circle being closed, a sigil written. The passing man outside hears the screaming, human and inhuman, coming from inside the house. He hears the sound of furniture and bodies thrown and crashing inside. He sees the winged thing, so much like a devil, emerge from the chimney, perch momentarily atop it, and regard him, pityingly, with infernal eyes. It spreads its black leathery wings as though in a creased smile. It shrieks a cry with no soul behind it, and lifts off into the daylight.

JOROGUMO

He realizes finally that he is too late when he steps into the darkened house and, as his eyes adjust, sees that it is empty, save for the spiders scuttling along the floor, and the web-stuck bodies of men affixed to the walls. Her form changes. Her skin peels and blisters. Eight enormous legs emerge. *Pop. Pop. Pop.* Eyes multiply on her once-beautiful face. Fangs emerge, and sink into him.

———

THE SPIDER IS REAL. The jorō spider that has contributed its name to the infamous spider woman yōkai (a Japanese term for supernatural creature or phenomenon) has striking red, yellow, and black coloring. At least the females do. They're also four times as large as the drab little males, whom they sometimes eat after mating.

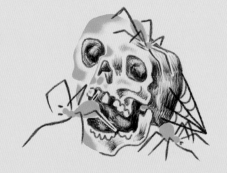

46

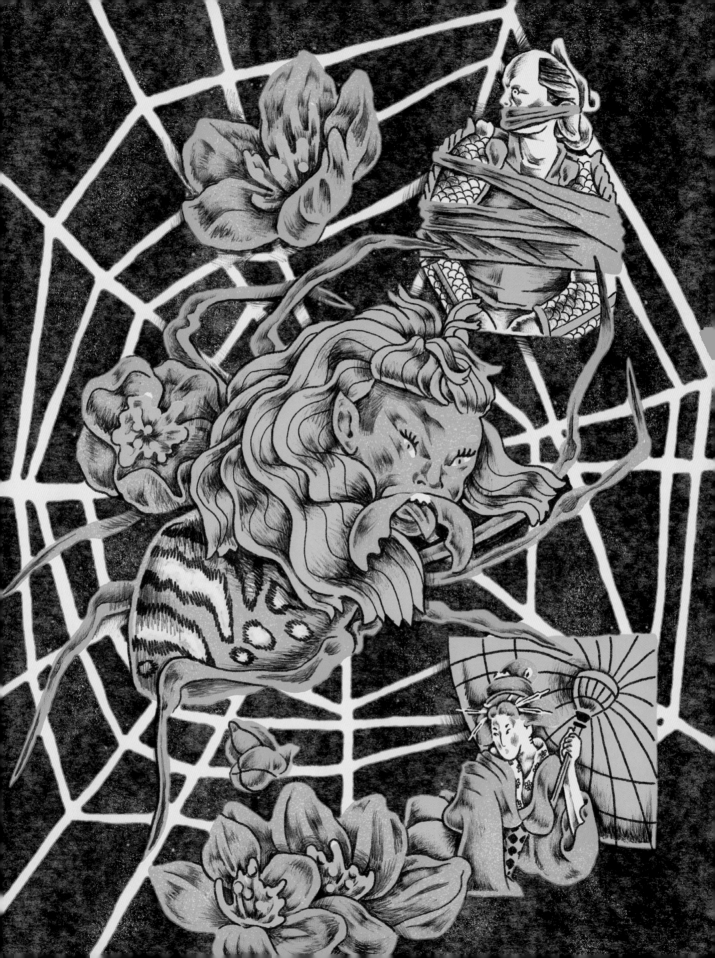

According to legend, when a jorō spider lives for four hundred years, she is invested with magical, shape-shifting powers, and is able to move at will between the forms of a beautiful human woman, a larger-than-human female spider monster, and others. She retains her appetite for eating males, but now they are lonely men—with her seductive human form a handy lure. A jorōgumo can also control other spiders, including some that can breathe fire, as depicted by artist Toriyama Sekien in his 1776 book *Gazu Hyakki Yagyō* (Nocturnal Procession of the Hundred Demons).

Jorōgumo often spin their lairs in abandoned houses, but also inhabit caves and forests. By some accounts they are able to conduct their feedings over long periods of time, even years, from a single lair without detection, choosing the right men just passing through, and those unlikely to be missed if they disappear. No one escapes once they have been ensnared in their silk, which is five times as strong as steel.

Early tales of the jorōgumo often feature a samurai hero almost falling for her wiles, then coming to his senses and slashing her to death.

She leaves the husks of the men stuck to the ceiling beams, inside the house she's claimed as hers. The one who will soon become a husk is close to accepting his fate, but over these weakening days, his pain will sometimes twitch a nerve and send a delicious ripple through the webs that bind him.

Her little ones crawl in and out of the husks, casting webs of their own. Tasting. Learning. They will go off on their own and, when the time comes, shift-shape like their mother. Their slender red, yellow, and black legs will become beautiful in a different way when they are hungry.

No one will enter the house but those whom she invites, and no one will leave. It will take many years to fill the ceilings of the house. The presence of the men here inside leaves no notable absence outside. No one cares. At least, no one looks for them.

Her form outside the house—which she only leaves when she wishes to feed—draws intense interest from the men she seeks to attract. Their loneliness and lust season the meal. The flavor lingers over the initial feedings. Over time she'll also taste fear, exhaustion, and finally, resignation. Her venom breaks the men down slowly. When the twitching stops, the cycle begins again.

There will be another young man, perhaps strong against other men but with a crucial weakness. He'll be hungry. She'll be hungry. His kimono will be silk. Perhaps he likes the feeling of the threads against his skin.

Krampus

How bad do you have to be, he wonders. He's lying flat on his back, lights off, under heavy woolen blankets. Light snow drifts past the window. He's been pretty good this year, hasn't he? There have been a few missteps. He really had meant to pay for the candy. He hadn't meant to push his brother so hard out of the swing. No one does their chores all the time, do they? He hears faint bells approaching. Sleigh bells? He strains to listen. No. Not sleigh bells.

———

HO-HO-NO.

Krampus the Christmas demon delivers punishment to naughty children with his own wicked sense of holiday cheer. Thought to have emerged from Alpine region folklore traditions

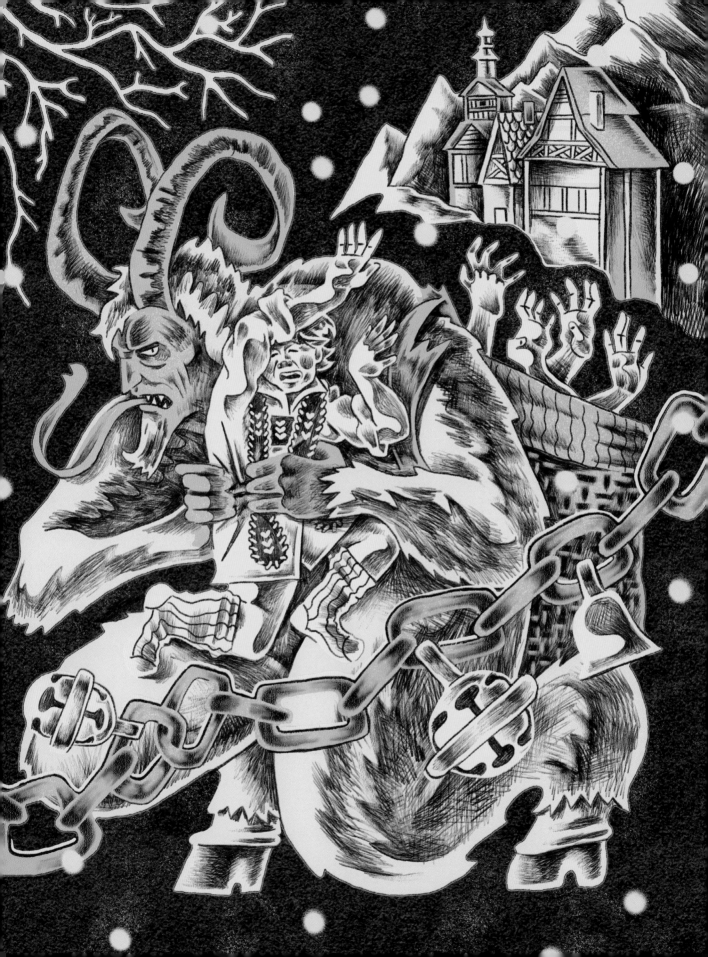

in which boogeymen come for misbehaving kids, Krampus came to be a yuletide-specific monster.

He is a fearsome sight. Part man, part goat, and part devil, he is covered in black fur and walks upright on his hind hooves or one hoof and one human foot. He sports claws and fangs. He may have multiple sets of animal horns sprouting from his skull. His tongue is red, forked, creepy, and always whipping around. He wears chains laden with bells that announce his arrival to the wicked.

He comes on the night of December 5th, Krampus Night, on the eve of the feast of St. Nicholas, a day when good little children will receive gifts from the kindly, white-bearded saint dressed all in red. No such luck for the bad kids. Depending on the seriousness of one's transgressions, they can expect anything from a lashing with a season- and region-appropriate birchwood switch to being stuffed in the sack or basket Krampus carries on his back, later to be eaten, or carried off into the fires of hell.

He is sometimes depicted as visiting children alongside St. Nicholas, rather than on his own the night before, which may be more of a convenient illustrative shorthand than anything else. As St. Nick transforms through shifting tradition into the more secular Santa Claus, along comes Krampus, each with their lists of naughty and nice, each of them smiling, enjoying their work.

'Twas the night before Nick's Day, when all through the house
Ev'ry child was stirring, each poor-behaved louse;
Their stockings torn down, which had once hung with care,
Demanding St. Nicholas with gifts to be there;
The children rambunctious and jumping on beds;
While visions of unearned cash danced in their heads;
When out on the lawn there arose such a clatter,
Kids sprang up to look and to foolishly chatter.
When what to their terrified eyes should appear,
But yule demon Krampus, his face all a sneer.
His long terrible tongue so deadly and quick,
The children cry out, each one frightened and sick.
More rapid than nightmares his curses they came,
And he cackled, and laughed, and called them by name:
"Now, *Dieter*! now, *Günter*! now *Inger* and *Johann*!
On, *Birgit*! on, *Roland*! on, *Eszter* and *Stefan*!
Come out to the porch, to the top of the wall!
I'll take away! Take away! Take away all!"
He was dressed all in fur, from his head to hooved foot,
And his clothes were all filthy with ashes and soot;
A bundle of kids he had flung on his back,
Who screamed bloody murder from inside his sack.
A wink of his eye and a twist of his head
Soon gave me to know that this world is but dread.
He spoke not a word, and went straight to his work,
More kids for his bag, which he cinched with a jerk,
And I heard him exclaim, ere he stalked from my sight—
"A hard lesson for them, to you all a good night!"

LA LECHUZA

Perched high in the trees, her claws gripping the branch, she rises to seven feet tall, with a wingspan twice that. She is big enough to run a car off the road. Her moonlight-catching eyes are ever observant, and she swoops down to steal children or drunken men, clutching them in her sharp talons to carry them away. She has been wronged, and she is angry.

———

La Lechuza's lore and potential hunting grounds cover northern Mexico and Texas's Rio Grande Valley. She is a hybrid creature with the body of an owl and the head of an old woman. In some tellings, she is a human who has the witchy power to take owl

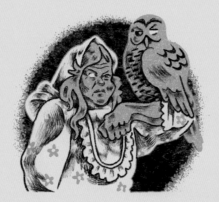

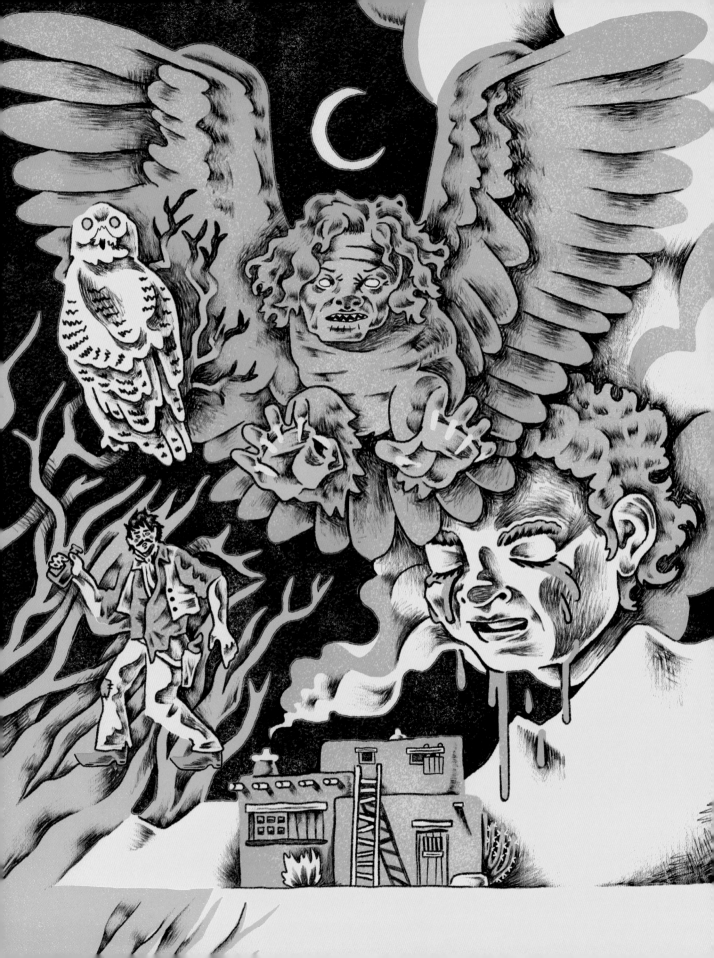

form. In others, she is the witch's familiar, a terrifying owl creature that does her bidding while wearing her mistress's human face.

Her origin stories often include a call for vengeance. She's an old woman living on the edge of town, suspected of being a witch (possibly true), wrongly blamed for a child's death, and killed by an angry mob. Or she's a woman whose child has been killed by a local drunk. Either way, a pact with Satan gives her the power of transformation, which she uses to kill abusive (usually drunk) men or take the children of the villagers who murdered her. And other children besides. She comes at night, and will sometimes make the sound of a crying child to lure her victims. During the day she retains her human form. Her familiar's most likely animal form is of a white barn owl.

Glancing encounters with La Lechuza can be fatal even for those she is not pursuing. Hearing her call can bring doom to a family member, and seeing or dreaming of her is a personal death omen. One touch of a feather from her wing brings death, but with that proximity, death is surely certain, regardless.

She's bulletproof. Salt may protect you from her if you sprinkle it in your doorways and window frames. In some stories, cursing at her will drive her away. In others, it will only make her angrier.

It matters, he thinks, that he didn't mean to hit the kid. The boy darted out of nowhere right in front of his car. He didn't see him. What was he supposed to do? He thought he hit a stray dog. He only found out what had happened, his part of it, the next day. He was drunk then. He is drunk now.

Town sure turned out for the funeral. He did too. Respect for the boy. The witch's boy. Well, not hers, exactly. The boy just showed up one day. Does that make sense? He doesn't really care. She's too old for the boy to be her son. How would that even work? Magic?

Not really a witch. Probably. What else do you call the old lady who lives off by herself? Might as well be a witch. She might as well have been the boy's mom, doting on him as she did. Doesn't matter now. No one knows. The boy is buried.

He leaves the bar and starts his wobbling walk home. He knows he can't be seen driving around right now. Someone might put it together. Connect the dots. Walking. Warm night. *Feeling no pain*, he thinks. Quiet night. No one out.

The screech jolts him. Up there, behind. He turns around and sees the shape coming in fast. What? An owl. A big owl. Not an owl. It screams again, and as it spreads its wings, he can hear its feathers brush together and feel their wind push his whole body backward a half-step. The talons dig deep, gripping him between his ribs and under his rib cage. His scream is sharp, and wet.

She carries him into the trees. As he chokes, she peers into his uncomprehending eyes, regards him with her human face, and screeches for the entire valley to hear. Her claws start to scatter him for animals to find later. She swivels her head and bites into his stinking neck, tasting his alcohol-poisoned blood through her human teeth.

As long as you respect the forest, you're probably fine. Leshy don't have any particular animosity toward humans, but they don't like anyone venturing into their domain and taking from it more than they need, or leaving it worse for wear. They also have a wicked sense of humor—and a propensity for boredom. They don't really need a reason to trick you into getting lost and starving to death, your body undiscovered except by the plants and animals it feeds.

———

CARETAKERS AND GUARDIANS of the Slavic forests of Europe and Russia, leshy can change their appearance at will, taking on any aspects of their forest, the creatures in it, and even the weather.

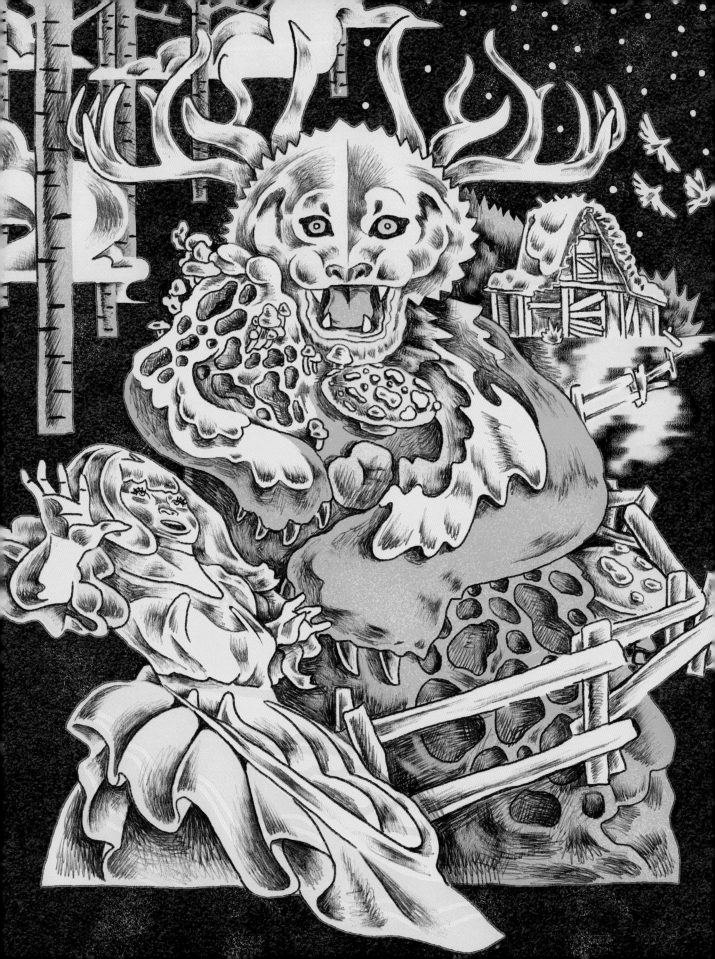

They can grow as tall as the trees or as small as a blade of grass. Mischievous wood demons, they amuse themselves by toying with humans. They will make animal or human sounds to confuse and tempt people deeper into the woods, change the terrain, send gusts of wind, and close paths—anything to disorient their captives. Kids breaking branches while out picking berries and greedy fishermen, beware.

Leshy generally are territorial and keep to their own forest. If another leshy intrudes unwelcomed, fights between them can cause terrible storms, wrenching trees and rolling boulders with destructive results. But they also love to gamble, and will sometimes risk parts of their forest in high-stakes games with other leshy, just to keep things interesting.

They may take the form of a demon (of the horns, hooves, and hair variety) or assume the shape of a bemused old man with long, green-gray hair and twinkling stars for eyes. In this form, with tree-bark-thick bluish skin, they may wander into a village pub, laughing and singing, just to see what's happening that night. When they want to menace humans, they'll assume a frightening hybrid shape (a mix-and-match of features drawn from trees, bucks, bears, wolves, and tigers).

To ward off or avoid tangling with a leshy you can make him laugh (they think wearing your clothes backward and shoes on the wrong feet is hilarious), avoid whistling or swearing while in his woods, or leave part of your hunt or harvest as a tribute.

On the first day, after he takes the rabbits, he thinks it is simply that he has gotten himself turned around in this unfamiliar stretch of forest. Maybe a little lost. Light fading, he considers his luck will be better by morning and curls into sleep.

On the second day, the morning light is thin, fogged over. It'll burn off, he thinks, but it doesn't. He can see, dimly, the sun and its motion, and walks as straight as he is able to manage over this jumble of terrain before even this light fades. He packs it in at night and eats one of the rabbits.

On the third day, the terrain looks familiar. He has been this way before. He is retracing his steps. His original path in. That rock again. This stream. This is good. He must be nearing the forest's edge. He'll be home by tomorrow. He eats another rabbit.

On the fourth day, the forest has tilted. As he walks upright, everything else is leaning some few degrees sideways. Tree trunks, plant stems, blades of grass. The birds in the sky, the stream under his feet . . . everything else follows this new plane. His leg muscles pull unnaturally as he walks askew. His eyes and head ache. He sleeps.

On the sixth day, he understands. He crawls to a tilted tree stump and places the remaining rabbits, and his water, at its center. He crawls away to wait.

A mossy, bark-covered hand many times his height reaches from the canopy of trees, from what looks like a tree. It takes the string of rabbits but leaves the water skin, turning its spout to a specific direction. He hopes it's the way out. The forest rights itself as the hand returns to the trees.

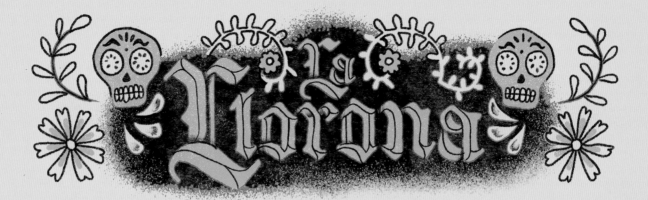

La Llorona

"*¡Ay, mis hijos!*" she cries out. *Oh, my boys!* She's a figure of terrible sadness, roaming in tearful desperation near bodies of water, areas like the one in which her own sons died. Her misery is real, but it also masks a murderous need: to find and take children, to replace the missing sons that she herself drowned in her futile hope that this will allow her spirit to pass into Heaven.

———

THE WEEPING WOMAN OF MEXICAN FOLKLORE is believed to have a number of antecedents in Aztec culture, including goddesses with aspects of crying, wearing white clothing, association with child death, and drowning.

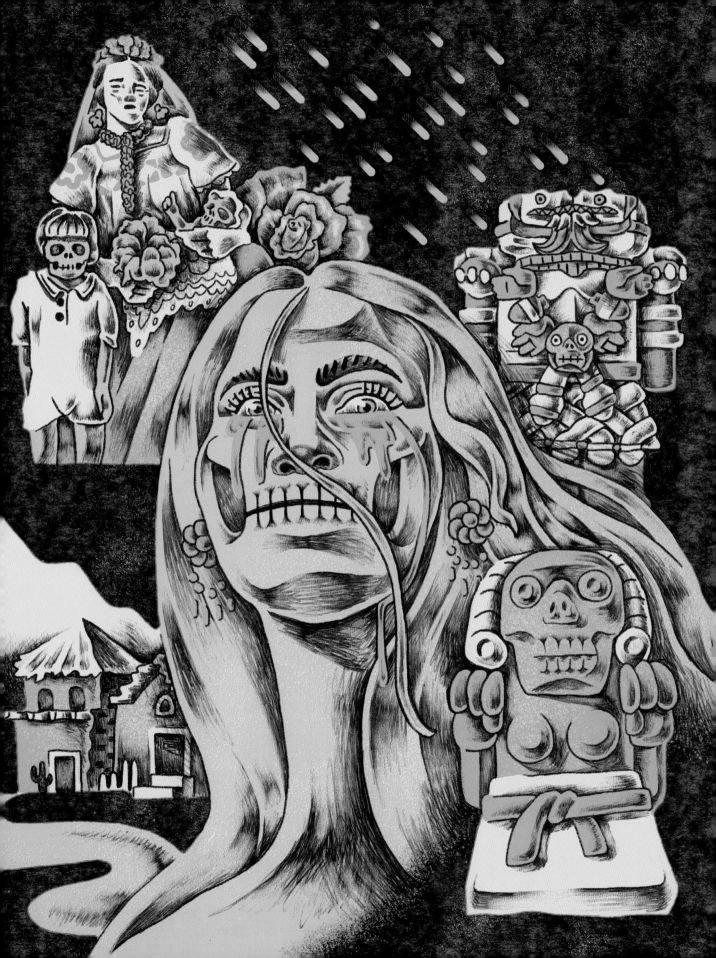

The most common version of her tale features a native Mexican woman who is married to a Spanish man of higher social status. The couple have two young sons. The husband then either leaves, is threatening to leave and take the boys, or is seen in the arms of another woman as their carriage passes the young mother and her boys while they walk near a river. Overcome by rage (or in some versions, intending to save them from a life of desperate poverty), she drowns both boys in the river.

Only when it is too late does she realize what she has done. Screaming, crying, and wailing, she either drowns herself then and there, or spends the rest of her living days wasting to nothing, delirious with grief, walking the riverbanks looking for her missing boys. In death, her spirit is cursed to haunt shorelines. She is still seeking her children, but she can find only the children of others, whom she will claim as her own—that is, drown them as well—to offer in replacement.

She's more likely to appear after it rains, and always at night. Accounts describe her as floating rather than walking on terrestrial ground. She wears a white rebozo partially covering her long, black hair. Her clothes are often wet. The bones of her dead sons are embedded in her back.

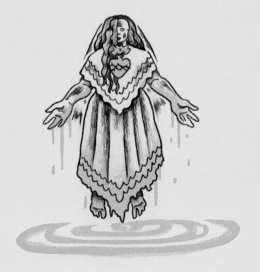

He knows he shouldn't be out here.

His mother would be worried if she knew. She worries about how he and his brothers are doing in school, about their homework, and bullies. She worries about money, taking in work she can do at home. He helps, before and after school, while his brothers are off running, and their father is off working. She seems tired. He worries about her.

Out here at night, he can pretend that he is exploring a strange planet. In the blue moonlight, a fallen tree is a wrecked spaceship. The trails lead to alien cities. Stones are ancient artifacts, or advanced technology—radios, tracking devices. The metallic insect sounds are otherworldly even without a leap of the imagination, and, as they are tonight, especially loud after it rains.

He hears her before he sees her. A wail begins suddenly from just behind the trees. It isn't there, and then it is. It's the sound of a woman crying, sobbing. Sad beyond anything. How can she be so sad?

As he makes his way through the trees, he sees the figure in white. She holds one hand at the side of her head, fingers touching her temple, behind her fingers and her temple, some unbearable pain. Her other arm is crossed tightly across her chest, protecting herself. Tears flow down her face as though pouring from a fountain. Too many tears. She's pretty, like his mother.

She looks up as he approaches. Wailing.

It's okay, he says. He touches her arm. *It's okay*. As she looks at him, her eyes soften for an instant. He doesn't see the way they correct themselves to fix on him for what he is: a boy, alone, on a riverbank.

She moves her arms to encircle him as he hugs her. He feels good. Her crying stops as she takes his hand in hers. He's helping her. He doesn't see the way her face flashes, a skull in the moonlight, as she holds his little hand and they walk together into the rushing water.

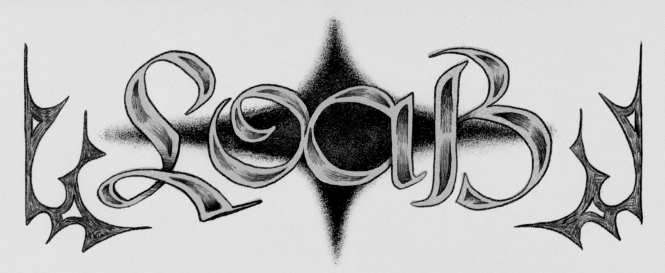

LOAB

She appears when summoned. Her hair is long and dark, her cheeks ruddy. Her eyes peer forward, are shrouded, or missing. Her expression is one of haunted sadness, or grim conviction, reflecting tragedy past or present. It looks as though she has been crying. For herself? For you?

IS SHE CONJURED, OR REVEALED?

 Loab is a spectral figure whose image occurs as the result of certain prompts entered into AI image-generation software. These programs draw upon massive amounts of data and billions of parameters to deliver what user prompts ask for. Given the scale, it's hard to know what, exactly, brings forth a particular result.

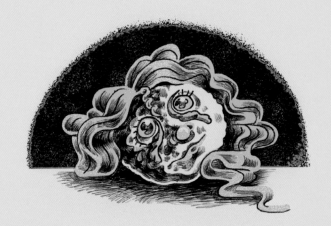

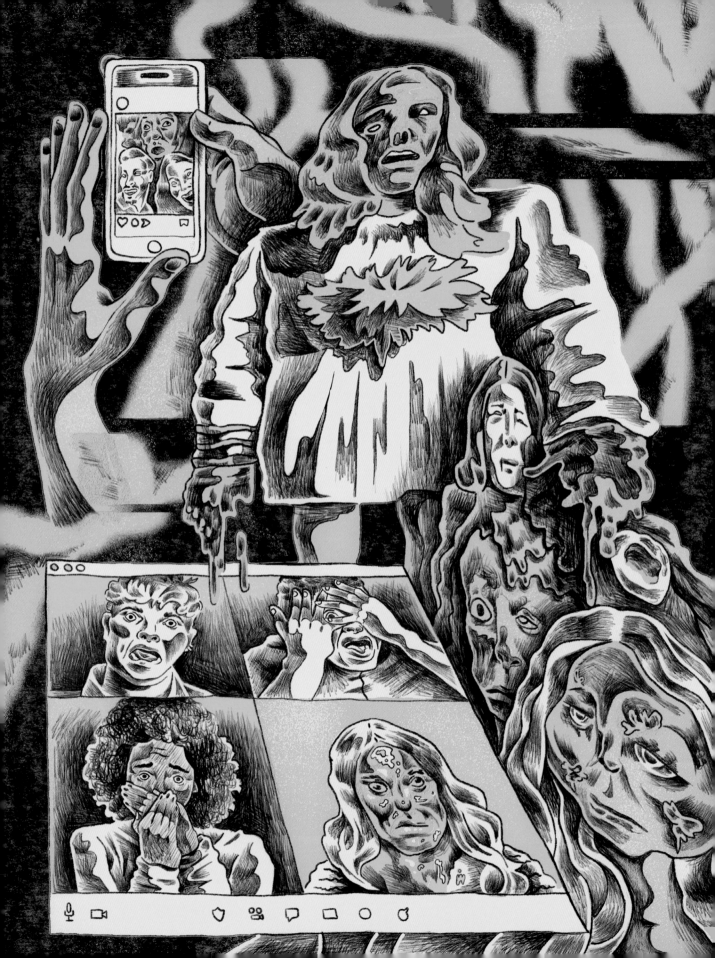

In the case of Loab, Swedish musician and artist Steph Maj Swanson says that she was playing around with negative prompt weights, which ask AI to find the opposite of whatever terms are entered. Searching for the opposite of *Brando* yielded Swanson a weird logo-like image featuring the letters DIGITA PNTICS. But when she added another negative prompt to this image, the AI produced not an image of actor Marlon Brando, but one of an intense woman who appears to be wearing a white shroud and holding flowers near her grief-reddened face. Among other AI-twisted typeforms in the image are the letters LOAB.

Swanson has been able to conjure other "Loab" images. When she tried "crossbreeding" the images of Loab with other prompts such as *bees* or *glass tunnel*, the experiment yielded subsequent images that ranged from silly to grim and creepy—but each one featured a woman with distinct features that keep her recognizable as Loab.

In another example of a creature delivered by an AI prompt, comedian Guy Kelly shared eerily similar images of a naked goblin delivered when he prompted AI to depict a *crungus*, a word he thought he made up. In this instance it seems to be easier to plumb the inner workings that delivered the result, including the word preexisting to describe monsters in games and appearing in the Urban Dictionary, and a visual kinship with the creepy Christmas monster Krampus.

Where Loab comes from is less certain.

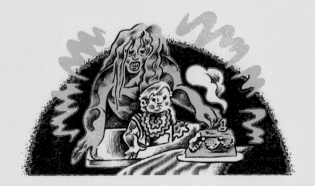

Some people are upset by AI, but he is playing with the image generators as soon as they are available. The future is here.

He knows he has to try to generate her. He starts with the prompts he sees in the articles about her. He has to see if it works. Fiddling with it, eventually it does. He tries combining her prompt with other elements, cartoon characters, superheroes. It's boring to combine her with creepy things. *Easter Bunny* gets a good hit. His train of thought from childhood decorations at home leads him to add the prompt *Mom*.

The image that arrives is a photo of his first birthday party. He's sitting in a high chair at the kitchen table. A box-made cake sits on the table, a candle in the middle. There are balloons. The digital woman looms in place of his mother, her hair draping down as she leans in to blow out the candle.

The photo print of the image sits unscanned in an album on his shelf. He goes to his sister's Facebook page. Here is the woman in place of their mother at the cabin they rented a few years ago, and tending their mother's garden, and at his sister's wedding. He calls his sister and asks her to look at the wedding photos.

Okay.

That's not Mom.

What do you mean?

Mom never had long hair.

She always had long hair.

Where are her eyes?

She never had any eyes.

He studies the photos. Studying.

Are you there?

I think you're right. This is right.

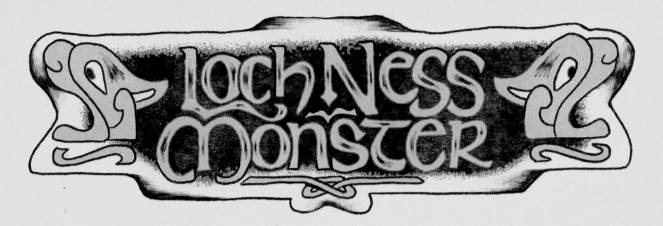

Loch Ness Monster

The terrible beast rises from its watery lair to brutally slay a villager swimming in the River Ness. Coming upon the man's funeral, a visiting saint touches his staff to the dead man's chest and he arises, once more alive. As the monster surges to attack another swimmer before their very eyes, the saint orders it to be gone. And so the creature is, for a while.

THE LEGEND OF THE MONSTER or monsters that dwell in Scotland's deep Loch Ness begin with this miracle by St. Columba dating to 565 CE. After that, it's largely unwritten folklore that keeps serpentine creatures swimming in the lake.

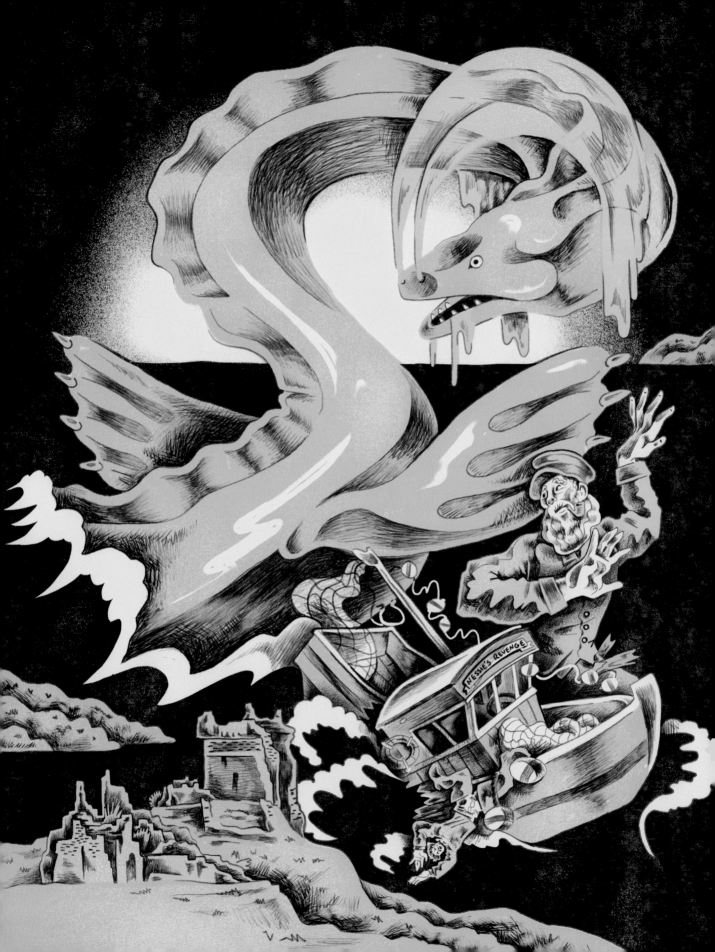

This changed when a 1933 article titled "The Strange Spectacle in Loch Ness" was published in a local newspaper, reporting a couple's account of having seen a whalelike creature "rolling and plunging" in the waters of the lake. That same year, the newspaper published the testimony of a local man who said he saw a creature resembling a long-necked dinosaur with a large, humped back, and thereby establishing some of the features attributed to Nessie in future sightings. (Researchers think he may have actually seen this creature swimming in the prehistoric waters of the just-released film *King Kong*.)

Photographs also began to emerge, including, in 1934, the "surgeon's photograph," the single most globally famous image of the creature. By 1994, however, it was revealed in an end-of-life confession to be part of a multi-person hoax to get back at the London *Daily Mail*, which originally published it. The hazy object in the photo is purportedly a toy submarine with a dinosaur head stuck to it. No more definitive proof has emerged since—no bones of Nessie's fifteen hundred years of ancestors, and no photos that are verifiably not something else.

Keeping hope alive, in 2023, the Loch Ness Centre and the group Loch Ness Exploration enlisted hundreds of volunteers and employed technology at a massive scale to try to see or hear the creature.

The drones that hum above scan the waters in infrared. The hydrophones listen below the waves. Boats teeming with observers spread across the surface of the lake. All watching. Waiting. Listening.

They cannot see the moment, centuries before, when the creature loses its patience with this particular fishing boat, dragging this net, on this dark night, and thwacks the tar-sealed, coffin-nailed hull with its tail. They do not see the boat and crew jolt, and the men aboard cast looks of confusion, and fear. There is nothing here, nothing to hit, in this deep middle of the lake.

They cannot hear the hull begin to crack as the creature delivers to it another sharp hit. They can't see, as the crew does, the huge shape break the surface and send ripples across the night waves. Grabbing hooked poles and standing at the edges of the deck, the men watch for it to resurface.

The observers may yet discover the remains of the boat, and the men, but they can't see the moment when the future of the men and the boat splinters, and each begins a journey to the bottom of the lake. It takes some minutes for the boat to slip below. Men fishing on the lake know that to go over and stay in the water is the end. The cold heavily fills wool and boots and pulls downward, filling lungs.

What the observers now would give to see the creature then glide around the sinking boat, uninterested in the sinking men, to pick a squirming fish out of the dragging net and take it down in a bite. Then another fish, and another, before the net unravels to let the fish loose again into the creature's lake.

Loveland Frogs

They are too big for frogs, though how big can a frog be if it's a kind you've never seen? Their near-human stance—do frogs stand on hind legs?—is all wrong. So is the grip the middle frog has on an upraised stick. The stick begins to glow, raising the hair on the back of your neck and arms.

———

THE FIRST ENCOUNTER with these strange creatures occurs in 1955 in Loveland, Ohio, when a traveling salesman who is out driving after midnight sees three humanoid, frog-like things standing on their hind legs by the side of the road. They have bumpy gray skin and webbed hands. They stand about four feet tall, and one of them is holding a sparkling wand over its head.

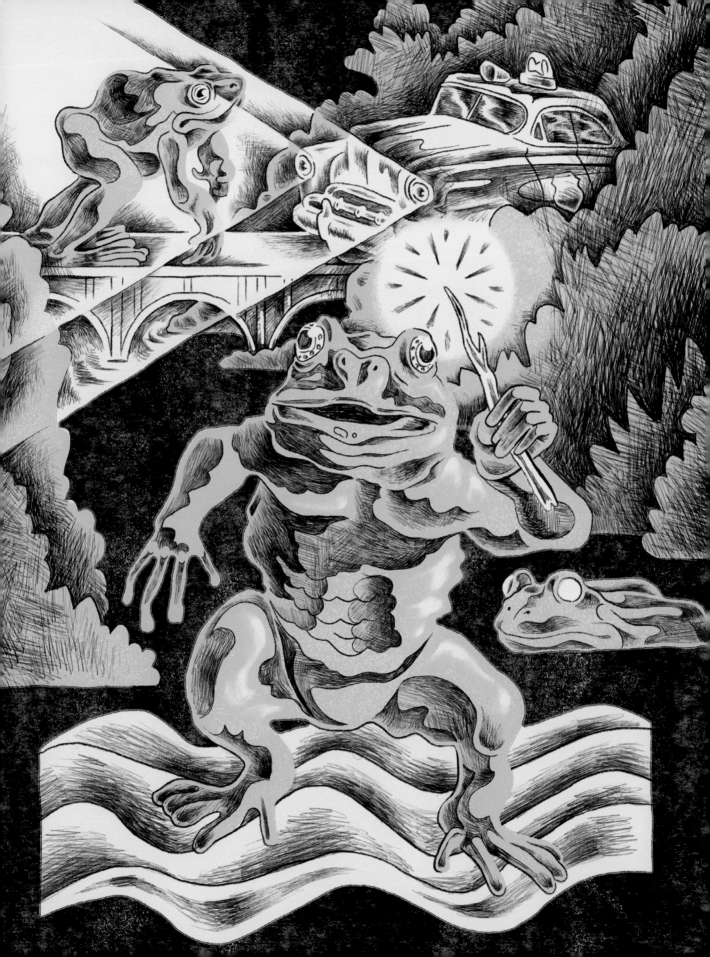

The next encounter, with a local police officer, is better documented. At 1 a.m. on March 3, 1972, Officer Ray Shockey spots a strange creature in his headlights while driving in the vicinity of the Little Miami River. It's leathery, frog-like, and standing on its hind legs. Startled, it runs across the road and hops a guardrail, headed toward the river.

Two weeks later, Officer Mark Mathews is driving in the vicinity of Shockey's encounter when he sees what looks like an animal carcass in the roadway. As Mathews walks toward it, the creature leaps up and begins to run away, at which point Mathews shoots the creature and puts the thing in the trunk of his cruiser. He wonders if it's the same thing that Shockey had seen.

The next consequential sighting happens on August 3, 2016, shortly after the release of the phone-based monster-catching game *Pokémon GO*. A player is out nabbing digital critters when he says that he sees a giant frog emerge from nearby Lake Isabella and walk away on its hind legs. He takes a dark video of something with glowing eyes, and a grainy photo brightened to show a dark thing that seems to be standing in the lake. Both are featured on local TV news.

This coverage prompts Mathews to come forward. When he showed Shockey the thing in his trunk, which turned out to be a deathly sick iguana missing its tail, Shockey confirmed that it was what he saw. "It's a big hoax," Mathews tells a reporter. "There's a logical explanation for everything."

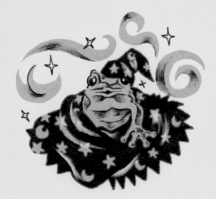

They had been men, once. But the magick had gone wrong. The enchantment that was meant to bring animal strengths to their human forms instead cast their consciousness into these amphibian shapes.

After the incantation and spellcast, there is a flash. As senses adjust, the night is sharper to their sight. They breathe the air through lungs and skin. Their robes fall to the ground around them, and they regard each other through bulging eyes, at half the height of a moment ago, with much else changed besides.

They had not intended that the animal power be that of a frog, but frogs now they are.

Confusion and shock turn to panic, and the need to cover themselves somewhere wet. To speak is now to croak, but they are relieved to understand. They leap together, on legs they find with unexpected pleasure to be very strong.

He who leads them, whose unfortunate idea this was, knows that he must retain the wand. Without the scrolls and tomes and papers, the wand is probably their only connection to the magick that, when set right, may restore them to their human forms.

He will have to try to remember the spells that he has read, but not yet tried. Illumination. Protection. Transmogrification. He will probably also have to improvise, and invent, though he now understands the consequences of being imprecise in this better than any other practitioner—except, of course, for his pondmates.

The desert sand rises to reclaim the space of
this small abandoned village in the United Arab
Emirates, surrounding its mosque, flowing through
the open doors and window frames toward the
ceilings of its dozen homes. The debris of wooden
furniture occasionally pokes out of the drifts—
perhaps too heavy to carry, or to carry quickly.
Al Madam is a place marked by eerie absence. A half
century ago, the village's residents left, or fled. What
drove them out? Where did they go?

———

THIS SECTION OF THE LARGER TOWN of Al Madam was constructed
in the mid-1970s, part of a modernizing effort by the newly founded
UAE to provide housing for nomadic Bedouin (town residents

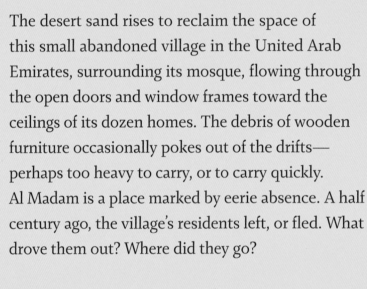

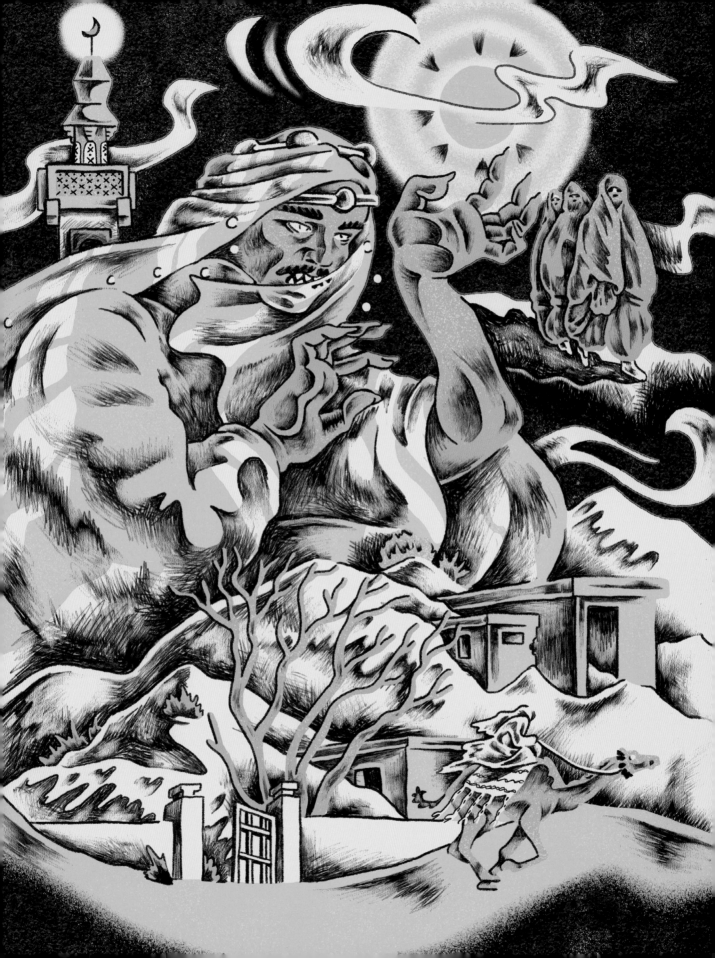

recall a tent site occupying the area before the buildings went up). By about 1985, all the residents had left, which locals at the time hadn't considered particularly remarkable. Townsfolks used the site as a sort of novelty campground, sleeping on the rooftops of the abandoned buildings.

Decades later, in 2018, online videos and photos of the sand-choked buildings fueled speculation that quickly turned to the paranormal. Some wondered if djinn drove the residents away.

Supernatural spirits with a cultural history predating Islam, djinn are generally invisible, shape-shifting beings that live in a realm of their own, though they may easily pass into ours. Djinn may be minimally or keenly interested in humans and our activities. Their behavior toward us may be benevolent or malevolent, mischievous, and even romantic.

Perhaps the government housing built in the area was substandard, with utility infrastructure for water and power poorly set up or maintained. Or perhaps, because the area is prone to hellish sandstorms, residents couldn't or didn't want to stay if they had other options. The mundane logic of these scenarios could explain why nobody paid much attention as folks moved away.

Or it could be that the djinn in the area just didn't want to share it with human neighbors—and so terrified them that no one would dare speak of Al Madam again.

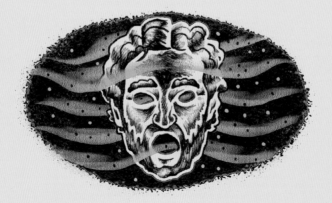

I t starts with the lights. Switching on to off, off to on, flickering, whatever is most annoying. Taunting him. But the power has always been dodgy here. Nothing works now. Try to get anyone out to do repairs now that he's the last one left.

House by house, family by family, they left. There are plenty of reasons to pack up and go. But the decisions to leave come quickly. One day, the same as yesterday. Then everything's strapped to the car and they're on their way.

Next, things just end up on the floor. He doesn't see them slide or tip off the shelves or counters. Okay, so this is it. *This is the best you can do?* He shouts this, his voice echoing off the walls.

The next day he awakens to his mother sitting at the edge of his bed. She's just as he remembers her from the last time he visited her in Cairo, where she lives, and certainly must be right now.

You were always stubborn. Tsk. This will not end well for you.

Nice try.

His mother becomes a shrieking, clawed, and fang-baring thing of blue flame. He jumps—he can't help it—and the djinni doesn't bother to hide his amusement. It's worse when the djinni stops screaming, and comes close to whisper in his ear.

I don't have to take you. The sand will.

In an instant, the house has lost its doors and windows, and the sand fills the room, fills his mouth, his eyes, his lungs. Then the doors are back, and the sand is gone. He still feels it in that moment before the sand is back. Switched on, off, on. It's time to go.

MAN-EATING TREE

The slender delicate palpi, with the fury of starved serpents, quivered a moment over her head, then as if instinct with demoniac intelligence fastened upon her in sudden coils round and round her neck and arms . . . the tendrils one after another, like great green serpents, with brutal energy and infernal rapidity, rose, retracted themselves, and wrapped her about in fold after fold, ever tightening with cruel swiftness and savage tenacity of anacondas fastening upon their prey.

———

EXCEPT THAT THEY DIDN'T. The "Man-Eating Tree of Madagascar," whose first described victim is a woman, was a hoax. It was first publicized in the April 26, 1874, edition of the sensationally inclined *New York World* newspaper, in the form of a breathless

82

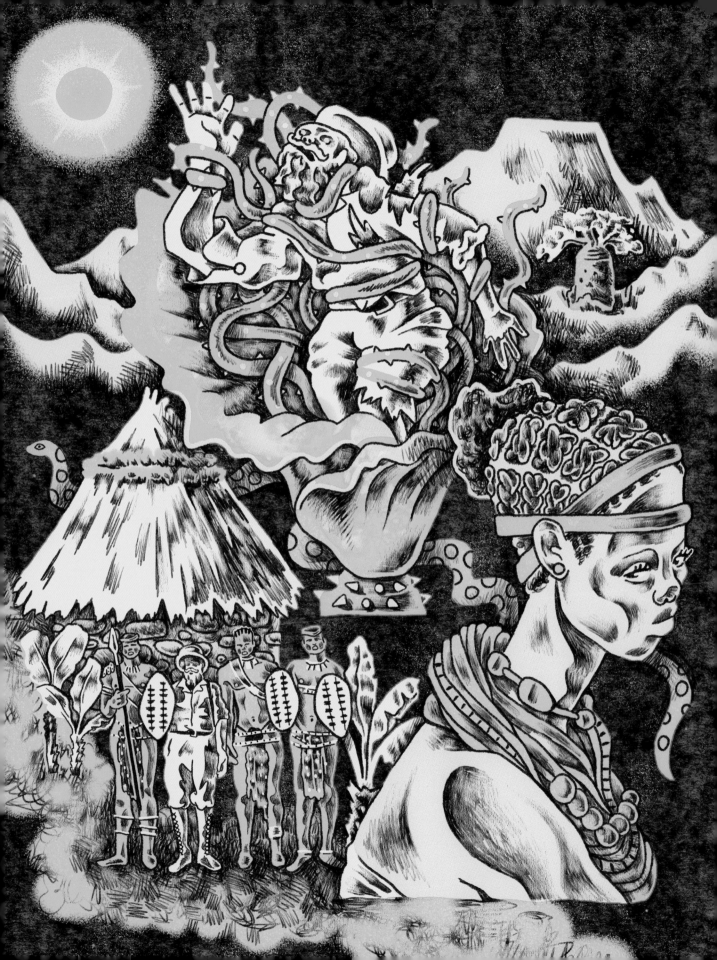

letter purportedly written by a German explorer. His account describes coming upon the tree as it devours a screaming woman, in a ritual sacrifice perpetuated by an equally fictional tribe. Striving for a factual feel, the article goes into paragraphs of detail on the tree's features, including eight-foot-long hairy tendrils and a sleep-inducing, honey-esque liquid inside its cone-like mouth.

The piece was later revealed by the magazine *Current Literature* to be completely made up by one of the *New York World*'s reporters. But the initial story was published or picked up in numerous other papers, and expeditions to find the fearsome tree were still being announced into the 1930s.

It doesn't necessarily help that in 1924, former Michigan governor and enthusiastic world traveler Chase Salmon Osborn published a book titled *Madagascar: Land of the Man-Eating Tree*, which describes his time and experiences in the country, as well as research he conducted in international libraries. In his introduction, pledging to be honest with the reader, he says:

> The purpose of this chapter is at once to enmesh your interest.... I do not know whether this tigerish tree really exists or whether the bloodcurdling stories about it are pure myth. It is enough for my purpose if its story focuses your interest upon one of the least-known spots in the world.

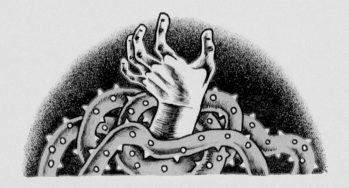

The man at the port explains slowly, carefully, that there is no such tribe, no tree. The story is made up. But this cannot be. The accounts are authoritative. His friend at the Explorers Club detailed his own encounter with the man-eating thing firsthand. Drew him this map, at which the portman shakes his head.

He can barely contain his rage. He's the first to admit his voice booms when he's upset. And that he's prone to thump and kick, in this moment at his own luggage cases. But this is truly outrageous. He's shouting. All lies? Are you lying to me now? What are you trying to hide? He is focused on the flinching portman, but he means to indict everyone bustling around him. The shouting continues. The portman closes his eyes. He takes a deep breath.

There is another plant. I can take you.

Well, it's about time! Why didn't he say so before? They'll leave tomorrow. The portman will meet him at the hotel.

It's a long drive, and the roads are terrible. How do people tolerate this? Eventually they are on ground that can't be called a road, and they arrive at a village.

Villagers talk to the portman for some time. A young woman gives him a sideways glance that he doesn't like. Finally, the portman says that he should follow a path leading into dense vegetation. No one follows him in.

It's not quite as described, rather more like a flytrap than a tree; but if the portman is to be believed, it's another species. He is leaning toward the plant to examine the inside, which is lined with tongue-like blades of grass, when thorned tendrils rise from the ground, snare him, and dump him into the mouth, headfirst. A new flavor of meat to join the slow-dissolving carcasses of a leopard, deer, and hare.

Mothman

It's not the Mothman himself that you need to worry about. His red, glowing eyes, seven-foot height, bat-like wings spanning wider than a car, and penchant for lurking in the dark may make him appear sinister; but he doesn't seem particularly interested in attacking people. Instead, you should worry about the danger his presence may foretell.

———

In the area around Point Pleasant, Virginia, there are accounts of something like the Mothman dating back to the 1900s. But it's in 1966 that the tale truly begins, when on a cool November night, two young couples driving around the dirt roads of an abandoned factory site see something in their car's headlight beams. They describe it later as a tall, humanoid figure with red-lit eyes

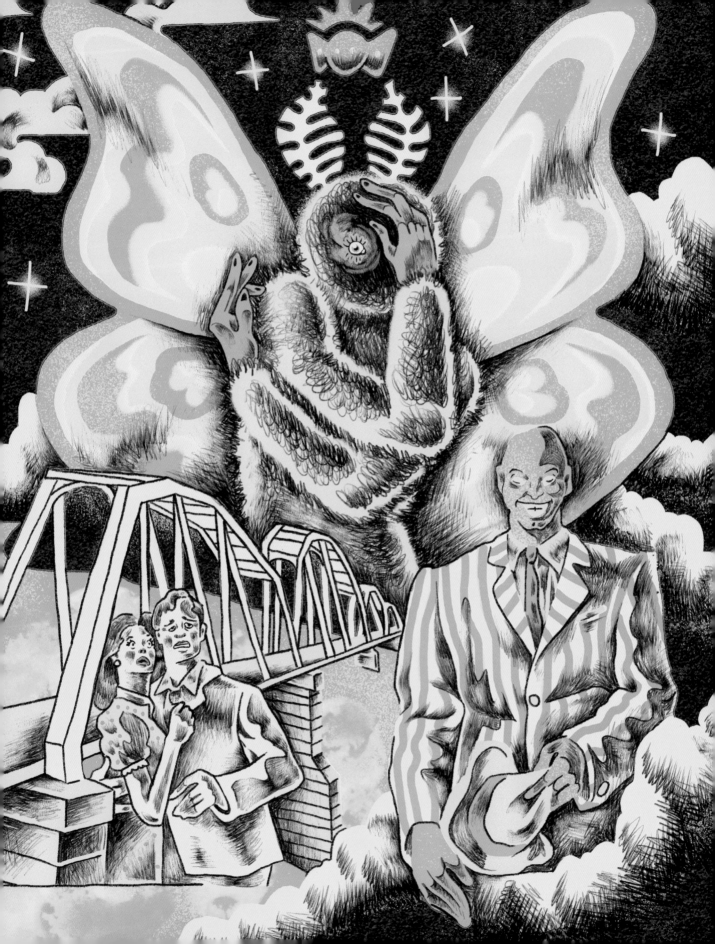

and huge wings extending from its back. As they drive away, it takes flight and pursues them, making a high-pitched screeching noise.

The next day, the local newspaper published an article headlined "Couples See Man-Sized Bird . . . Creature . . . Something," and for the next thirteen months, Mothman sightings and other strange phenomena are reported throughout the area. UFO sightings abound, as does an account of a fiercely grinning man dressed in a suit who speaks telepathically and seems to be not-of-this-Earth. Elements of the Mothman sightings fit with what you'd expect when encountering one of the large-winged species of bird common in the area (including the red-eye effect when light hits human and some animal pupils just right); but with him looming in the imagination, the other weirdness just accumulated around him.

People also reported having vivid, death-stalked nightmares, including one about people drowning in the nearby Ohio River. On December 15, 1967, the mile-long Silver Bridge connecting Point Pleasant with Gallipolis, Ohio, collapsed, sending forty-six people in their cars to their deaths at the bottom of the river. Mothman's presence is then understood then as a possible warning or harbinger of doom. Soon after, sightings in the area taper off, with whatever role Mothman played in the local psyche having been fulfilled.

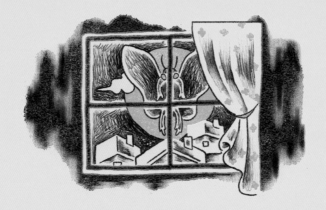

The nightmares have been getting worse. They're no longer just the on-the-nose anxiety transference dreams—the final exam for a history class she's never attended, in a room she cannot find, a decade after she graduated from college. They're stranger, more unsettling. She wonders how much of this has to do with the new sleep medication she's been taking, which has yet to keep her asleep, but has been turning dials on the TV shows inside her head.

When you can't stay asleep, or you've woken from a nightmare that you do not want to slip back into, she's heard that it's best to get up and change your surroundings. Standing at the kitchen sink, drinking a tap-warm glass of water, did she really see a man with glowing red eyes crouching on the neighbor's roof flap away on huge wings into the night?

The nightmare tonight and for the past few days has been of water. She's in a tight glass room, in which she can only half spread her arms to touch the sides. She can see other people in glass rooms like hers, all of them in dark water. All sinking. Wide-eyed. Some make screaming motions, but she can hear no sound. She sees one woman begin to pound on her glass space, and she tries to warn her to stop, that that she will let the water in, but she can't speak, and there is no sound.

Until she hears the beginning of a crack in her own glass. She can see it spiderwebbing slowly outward from her fingertips. She had been touching, pressing too hard. If only she had known. She tries to shout out, to plead, but the cracking is the only sound. And now it's too late.

NURE-ONNA

Her taste for human flesh and blood causes her to rise from her watery domain. Deception is her first tool. Once she has tricked her intended victim, her hold on them is both physical and metaphysical—twice over, they cannot move. They will be pulled under, into her saltwater lair, to their doom.

———

WITH HER SEA SERPENT BODY, human head, sharp fangs, forked tongue, and appetite for fishermen, the supernatural monster nure-onna ("wet woman") stalks the shorelines of Japan's Kyūshū region and elsewhere along the country's many coasts.

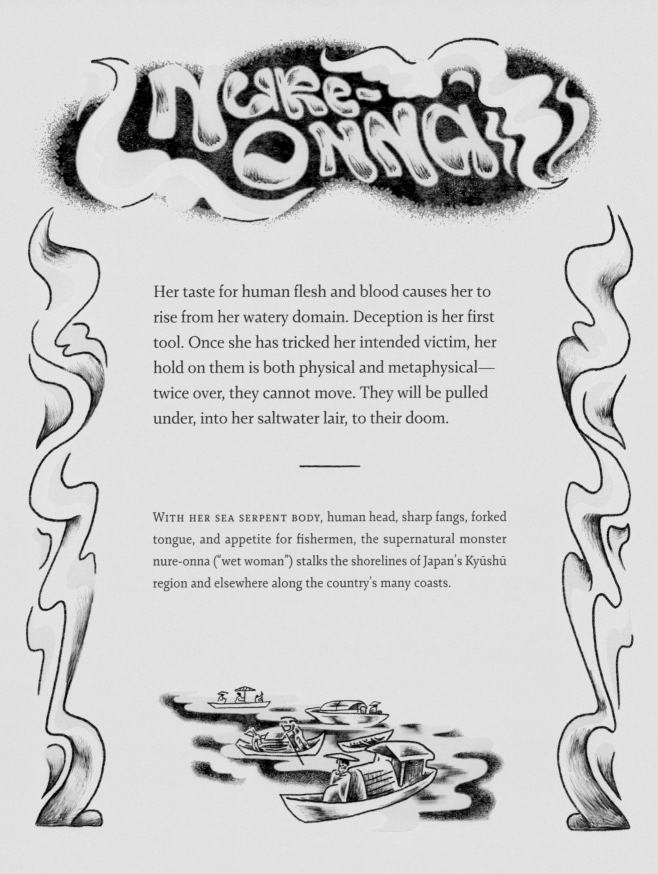

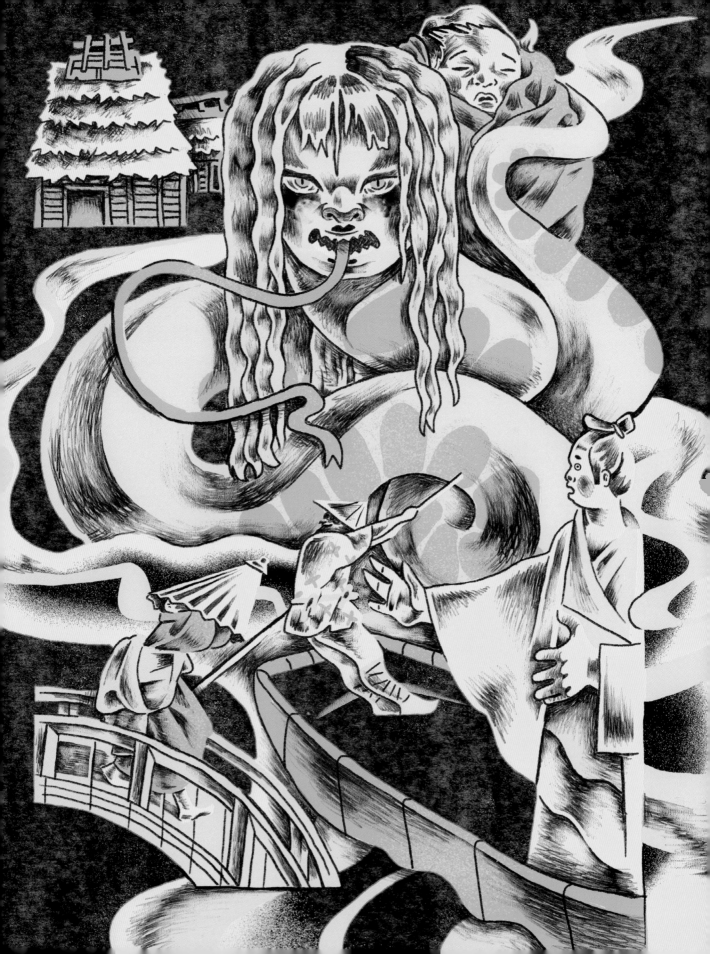

She's described in several forms, most commonly with human arms and head, and a snake-scaled body and tail that can measure one hundred feet in length or longer. In some tellings her face is hideous, and she keeps it hidden in her long black hair. In others she appears as a beautiful woman. In versions in which her face is attractive, she may bob it above the surface of the water, her body hidden below, to act as a lure.

The trick for which she is most famous is to stand at the edge of a saltwater body and either create the illusion that she's a normal human or somehow hide her serpentine portion from view. She holds a bundle that seems to be a baby, and she appears to be in distress. She will call out for help to unlucky passersby and ask them to hold her baby, which will suddenly become a stone of such mass that they are pinned in place. She will also look into the victim's eyes and fix them with a paralyzing gaze. And so they become her seaside snack.

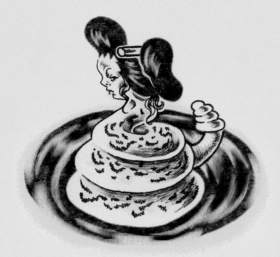

He sees her, and she sees him. He knows this story. He is electric with adrenaline. She has chosen him.

He knows, distantly, that he should be afraid. His grandmother warned him not to play alone by the shore. His schoolmate had drowned. *Taken by the wet woman,* the kids at school said. But he'd seen the boy in his wooden coffin—not sucked under the water and lost forever.

She's beautiful.

At first he doesn't realize he has stopped in his tracks, but he also doesn't notice when he begins walking toward her again. Events proceed as they must.

He knows she's going to offer him the bundle, the baby that isn't a baby. He wants to tell her that it isn't necessary. But he's also curious.

She has green eyes. Her pupils are sharp, like fangs.

It's not that he can't move. He feels deliciously alive in her gaze. Who else has a chance to feel this? It's him that she wants.

He can see a flash of iridescence emerging from the water behind her. The tail. As it coils around him, he feels a comforting pressure.

Her hair is wet.

Her tongue flickers on his neck.

Fangs in.

He has been chosen.

ONRYŌ

Alive, still, at the bottom of the well. She is in black water. The only light, which shines narrowly through gaps in the boards high above, is a lie, from the days with any hope. Only darkness now. Her fingernails are embedded in the unclimbable walls. They will, one day, find her bones. They will feel her rage.

———

AN ONRYŌ IS THE VENGEFUL SPIRIT of a person who has died an unjust, untimely, or even violent death. They are beings of profound suffering and unresolved anguish, which they inflict on the living. They are pinned to this world by their grudges, unable or unwilling to move on.

They bring their wrath upon the people who have wronged them, sometimes dragging out their punishment to relish in the agony—inflicting illness, reversals of fortune, shattered relationships, and

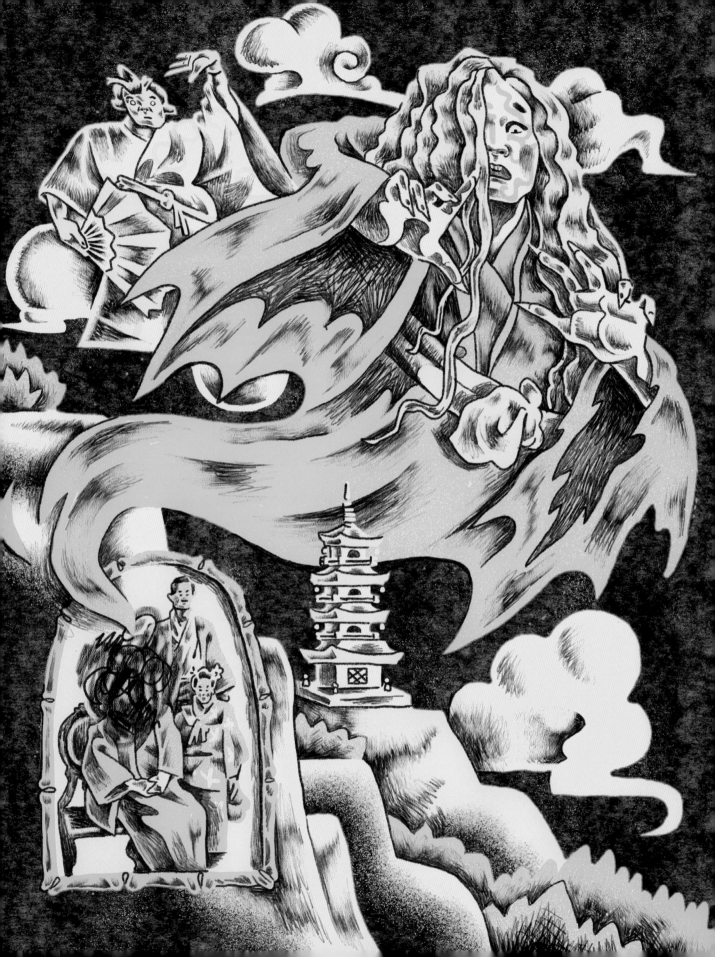

madness. But their rage can also be indiscriminate, raining down misery and death upon anyone who comes along. Their spirits can curse locations, but can also move freely and infect individuals, passing from person to person. They may also cause natural phenomena such as earthquakes and lightning strikes.

Often they are depicted as women with death-white skin and long, dark hair covering their faces, as in Japanese horror films such as *Ringu* or *Ju-On*. But onryō may manifest when anyone dies by violence or in unresolved anguish.

Classic examples include Oiwa, whose tale varies. In one version she is disfigured after using a face cream given to her by a rival for her husband's attention. Her husband then launches a terrible plot against her. Dying by accident as she seeks revenge, her angry spirit—bearing the marks on her face from the cream—convinces her husband to murder his new wife and father-in-law on their wedding night.

There's also Okiku, who is murdered by a master whose advances she rejects, and whose body is thrown into a well. Part of his plot of manipulation involved him blaming her for a missing priceless heirloom plate. Her spirit exacts its revenge by roaming his halls and counting to nine, just short of the tenth "missing" plate. Anyone hearing this becomes sick and dies.

And according to local lore, careful maintenance of a shrine in central Tokyo containing the head of a vengeful samurai warlord named Taira no Masakado may manage natural disasters in the area.

Who took the delivery for the murder house?

No one in the office says a word. He looks down at the pink copy receipt in his hand.

Over at Sunrise Estates?

Yeah. You took it? I was going to cancel the order. No one should be going over there. You went?

He holds up the pink copy the company keeps on completion of a delivery, in this case a truckload of plumbing pipes and fittings.

Murder?

Yeah, you didn't hear? The husband killed the wife and their kid and then he killed himself. Nobody's been able to do anything with the place since because of it. I thought everybody knew about that. You went inside?

The house seemed run-down, but those are usually the places that need things like truckloads of pipes.

No, of course not. Left the pipes. No one to sign. Took photos to prove delivery.

Well, then you might be okay, if you didn't actually go inside.

What do you mean?

Angry ghosts. The place is cursed. But you didn't go inside. Maybe it's okay.

He had knocked, as unlikely as someone coming out of that grimed front door would be.

He wonders if that's what did it. Sitting here in his apartment now, looking at the phone photos from the delivery. Their white shapes look chemically burned into the photo pixels, their faces blackened, out in front of the house.

He doesn't know whether to keep the lights or off. It probably doesn't matter. He just has to decide how well he sees them when they come.

PESTA

The corpses are stacked by the side of the road, for the cartmen to take away. Their faces have been covered, but the crows have pecked the rags to seek the popped eyes and protruding tongues. The living stay inside behind closed doors, but still not safe. The occupants of this house cannot see the old woman in the red skirt, merrily sweeping dust from the front of their door. Their bodies will soon join the burden of the cartmen.

———

PESTA IS THE EMBODIMENT of the very real horrors of the Black Plague as it ravaged Norway beginning in the mid-fourteenth century (*pest* is Norwegian for plague). The plague's arrival there has been traced to an English ship that landed at the Norwegian

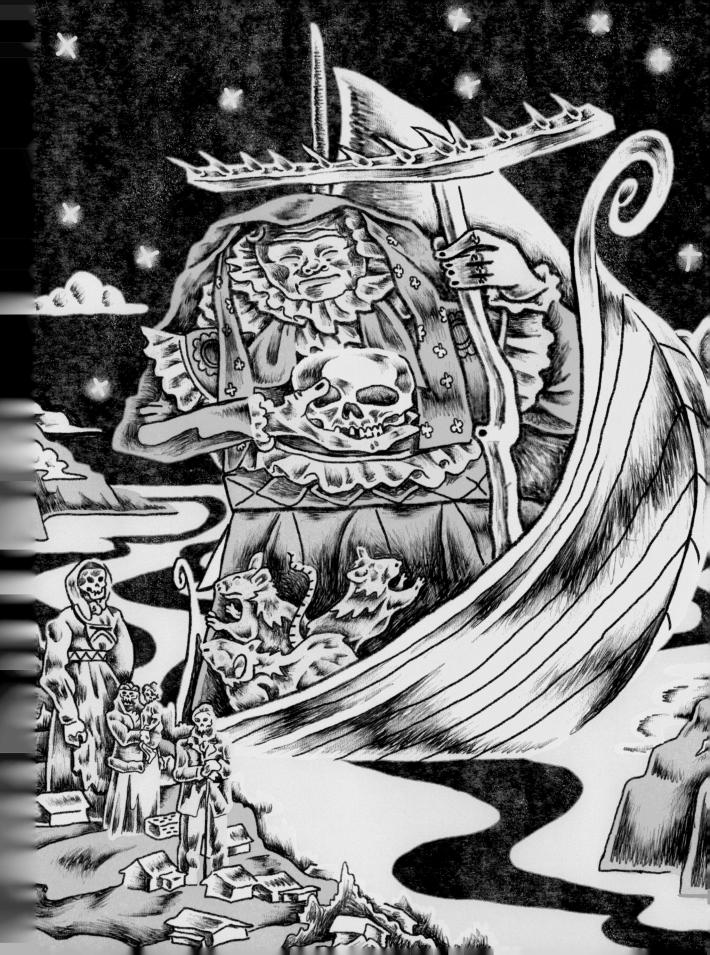

port of Bergen in 1349, and was carrying infected rats and fleas in its cargo hold. Believed to be spread through respiration and flea transmission, the plague killed as much as half the country's population in about six months. It's an almost incomprehensible tragedy, which calls out for some sort of storytelling framework to help it make sense.

Embodied in Pesta, the plague is no longer invisible to the eye. She is depicted as an old woman wearing a black, hooded cloak and a skirt that is usually, but not always, red. She travels the country by foot, walking from farm to farm and village to village. According to folklore she carries either a rake or a broom. Those who encounter her carrying a rake are the lucky ones—they or some of their loved ones may slip through the rake's teeth and be spared a horrible death. If she is carrying a broom, all will be swept away. Death comes within three days, and no one survives.

When she travels by boat, the ship will pull into the harbor with the crew all dead.

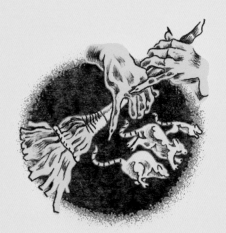

He can see her in blue on the riverbank, clear through the stubborn morning fog. There isn't much call for the services of the ferryman now. The healthy keep shelter, the sick wait for the end. But the air on the river is fresh, and what else is there to do.

He is not surprised to see her. Some older villagers still walk, not wanting to be prematurely entombed in their homes while some time is left for them.

To the far shore? he asks. She nods.

He takes her hand and helps her step down into the boat. He cannot see her face well under her hood, but it is common for people now to not want to meet each other's eyes. It brings a vulnerable feeling.

Terrible days, he observes.

She holds a large book on her lap, clasped in both hands. It seems of fine origin, but smudged. It is large, a pointless thing to carry. What need? He realizes. She carries the book of names. It is her.

But you are wearing blue.

So I am.

Please, he says. Please, do not take me. I am a good soul. I help those in need. I am helping you. Please. Consider the fare paid with your grace if you will spare me.

What is your name?

She opens the book three quarters to the end. Turns a page, scans it, turns another.

You are here. There is no other way. But I can leave the pain of it aside.

She touches his heart with the end of her staff. He drops in a heap to the floor of the boat, which continues on to the far shore without need for him.

A PISADEIRA

He really shouldn't have eaten that second piece of cake, on top of everything else. But why not? Flat on his back in his aunt's spare bedroom, his weary eyes pick out a red glow that might be a digital clock, except that it laughs at him. Her red eyes fixed on his, the spindle-limbed old woman long-steps her way over and up and onto his chest. It's hard to breathe. He can't move, neither awake nor asleep. She laughs again, her green teeth bared in a satisfied grin, enjoying herself. He can't breathe.

———

IN BRAZILIAN FOLKLORE, those who overindulge in eating at night and sleep on their back may be inviting a visit by A Pisadeira (*she who steps*). She is tall and skinny, with a tangle of long white hair,

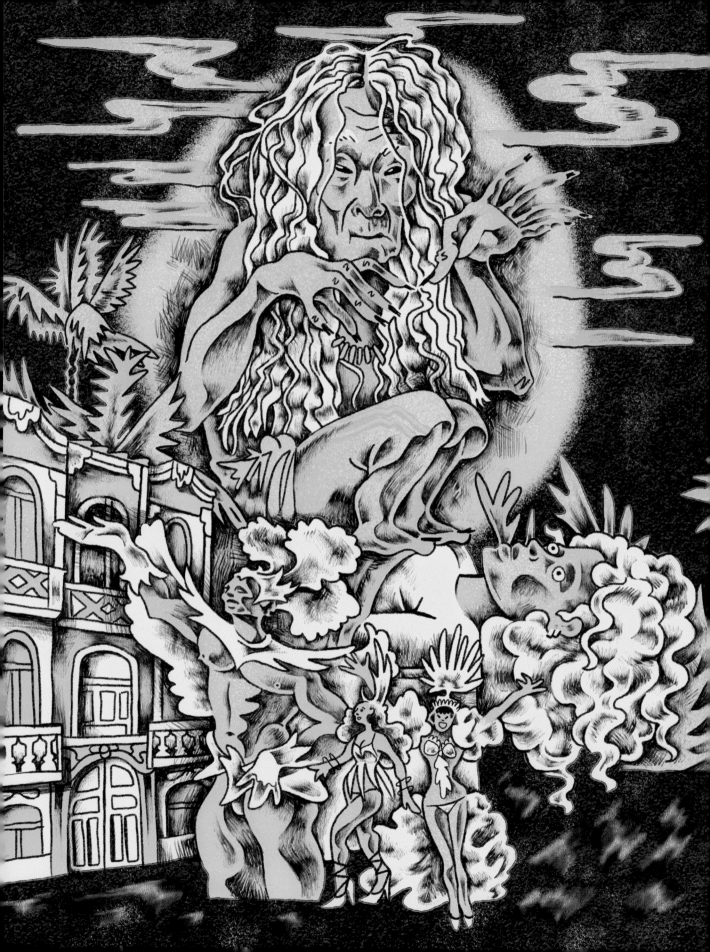

and filthy long nails. A Pisadeira will climb onto the victim's torso, making it impossible for them to move, and very difficult for them to breathe. She'll peer into their eyes and watch their mounting panic, relishing and feeding off their fear. She is also known for her witchlike cackle, a sound that only increases the terror. She does not seek to kill. It's instilling in her victims the helpless, intense fear of imminent death that is its own savory reward.

A cautionary figure meant to warn people off sleeping on their backs and eating too much—two states that can result in uncomfortable or broken sleep—A Pisadeira is also a folk manifestation of the frightening condition of sleep paralysis. In this state, a sleeping person will feel conscious, locked in a vivid and semi-lucid dream state in which there is some terrible threat and a need to react, though they find themselves helpless and unable to move or speak. It's thought that this is the result of the dreamer passing into or out of REM sleep, when our muscles are naturally paralyzed to aid in the sleep cycle.

But maybe it's the bony, pale figure crouched on the rooftop across from your window, watching you eat, peering in with her glowing red eyes, who will come visit you in the night, when sleep turns you in just the right way.

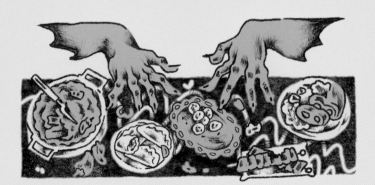

She waits across the alley from the family's big-paned windows, crouched, her claw fingers hooked underneath the ceramic roof tiles. She does not mind waiting. She enjoys seeing them eat. This will also feed her.

It's difficult to choose among this group tonight. So many, so much delicious indulgence. A celebration. Spirits high.

She chooses the youngest boy. Anyone would do, but the fear of children is sweet, grassy. It has been a while since she's tasted that flavor. She, too, would indulge tonight.

After all the lights are out in the house, she is inside his room. For a while, she watches him dream. Something unhappy. He twitches. She's close enough to see his eyes dart under their lids. He's lying on his left side, then his right, then left. Snoring lightly. She waits.

When he is on his back, she announces her presence. It is more nourishing if they are afraid. *Ehh ehh hehh hee ksshh ksshh ksshh.* At the side of his bed.

She watches him register the sound outside of his dream. As his eyes begin to open, she takes her perch, always only as light or as heavy as she needs to be. His eyes lock and dart, the only part of him that can move. Beneath her bare feet on his chest, she can feel the nerve and muscle impulses his body makes in an attempt to produce a scream. Her toe claws curl, contentedly.

She feeds for a while and moves on. The moment her weight is lifted, his coiled efforts spring him upright, and he screams. His hands go to the itchy scratches on his chest.

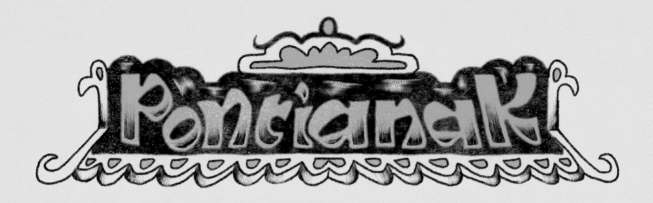

Pontianak

From above, she can see him react to the sound of her laughter. He stops walking and turns. Looking for her. She drifts down behind him with the sound of rustling leaves, and he sees her. He radiates an ugliness that she would find frightening when she was human, but it is what she looks for now. He brushes her hair from her face. She bares her fangs. His face registers shock as her fingers reach into his chest.

———

In Malaysian folklore, a pontianak is a vampiric, vengeful ghost of a woman who has died while pregnant or during childbirth, and seeks retribution from the men who have committed

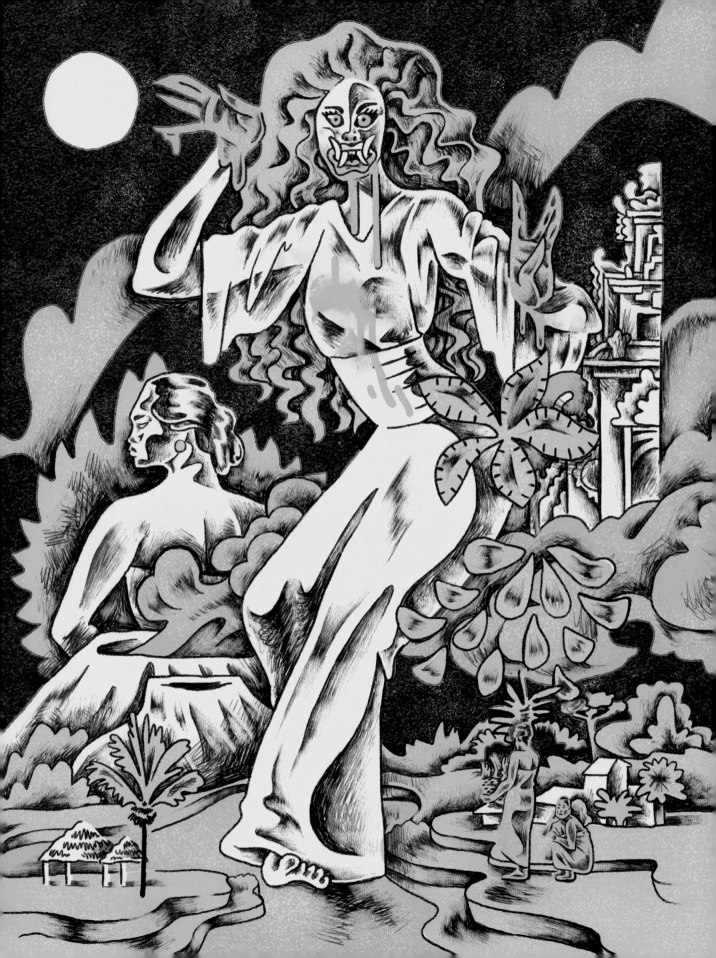

violence against her or directly caused her death—or have hurt other women. Living in and flying between the trees, hunting by the light of the full moon, she wants nothing more than to slice these men open with her long, blade-sharp fingernails and feast on their innards, opening an artery in their necks to wash the guts down with their blood.

She has long, dark hair that either drapes over her face, or is brushed aside to reveal her beauty. When her true self is revealed, her snarling face and pure white clothes are seen as spattered with blood, and the fangs and claws come out. Hearing a baby cry or woman's melodic laugh is a sign that she may be on the prowl. Counterintuitively, if the sounds are faint, she is close, and if they are loud, she is farther away—another trick. In her seductive form, she smells sweetly of plumeria blooms. Ready to strike, she emits the putrid carrion smell of the corpse flower.

A regional capital city in Western Malaysia is named after the ghostly creatures. According to legend, the area was inhabited by the spirits until the late 1700s, when they were driven away by cannon fire and, the settlers hope, kept away by clearing all the trees in which the phantoms make their homes. The Sultanate of Pontianak enjoys a reputation for defeating the fearsome monsters, and residents today recognize the lore by firing bamboo cannons on certain holidays. But, of course, the trees have long since grown back.

She sees them perched in the trees on her forest walks, their white robes evident in the light of the full moon. She sees them because she knows where to look, and because they do not mind her seeing them. They take no effort to assume their beguiling shapes, tracking her with interest but no appetite. Blackened bloodstains mark their robes.

She takes comfort in their presence. She feels safe, walking alone on these brightest nights when it would be dangerous otherwise, because she knows they will be there. As she walks, she is never more conscious of her body pulsing blood through her heart, lungs, kidneys, liver, intestines, and arteries. She thinks about how it must feel for the men they hunt, the men who deserve what is to come, when the first razored fingernail slips into their abdomen and rips upward, spilling their viscera out for feeding.

These men have already done what they have done—their violence begets this violence—but to stop them from doing more is something. Sometimes when they go missing, or are found and said to be taken by animals, she and others who believe know why it was that man. Other times, the behavior that takes them is more secret.

She is disturbed when she sees that her uncle has arranged needles, nails, and scissors along his windowsills and doorways. *Rats*, he says. She does not know what he has done, but she knows what the objects are really meant to keep outside. And she knows that eventually, on a night of the bright moon, they will find him.

EL SILBÓN

Where is the boy's father? They will have to eat without him. The boy will not be kept waiting. Not with the meat sizzling in the pan. At her elbow, he watches intently. *Go, sit*, she says. The heart is a bit small—maybe they shot a yearling—but the liver is odd, fatty. She overseasons to compensate. The boy forks several pieces into his mouth before she is sitting down. Where is his father? With her first bite she knows that the meat is wrong, between her teeth, on her tongue. It is not the meat of a deer.

———

A GHASTLY, MURDEROUS FIGURE between ten and twenty feet tall, El Silbón stalks the grasslands of the Llanos region of South America that spans parts of Venezuela and Colombia. He carries

110

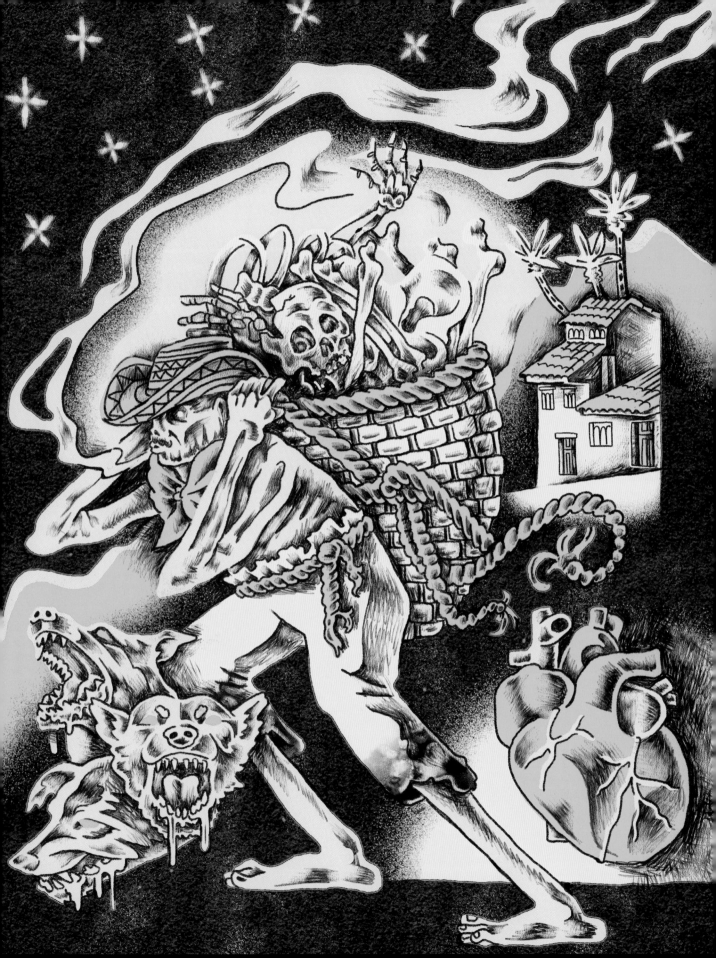

the bones of his father and his other victims in a sack or basket on his back. His approach is marked by an eerie, rising sequence of whistled notes. If the notes are loud, he's farther away. If the whistling is faint, he's right upon you.

In one version of the tale, El Silbón was once a young man in love with a woman whom his father hated, as he considered her beneath the family's station. When his son wouldn't leave the woman, his father killed her, and the son then killed him in a vengeful rage.

In another more gruesome popular telling, El Silbón was once a spoiled young boy who demanded that his father hunt a deer so that he could eat its heart. When his father failed to bring home a deer, the boy murdered him and brought his heart and liver to his mother to cook instead. She discovers the terrible truth only after they have begun to eat.

At this point the tales converge. The vengeful son's grandfather straps him to a tree and whips him—dousing the wounds with alcohol or peppers—then unties him and leaves him to be torn to shreds by wild dogs. But his grandfather also left him with a curse. El Silbón rises from the dead, corpse thin, his limbs uncannily stretched, and is doomed to roam the earth carrying the burden of his father's bones.

While suffering this fate throughout eternity, El Silbón also keeps busy, killing drunks and the unfaithful, or anyone unlucky enough to be roaming alone on the plains, with his whistle as his calling card.

She isn't taking chances. She brings one of the dogs with her and, though her father mocks her for it, a handful of dried chilies stuffed in a bag in her pocket. It doesn't matter what he believes. She's not going to explain Pascal's wager to him—that you might as well believe if the price of disbelief is so high. Basically. Plus the dog is having fun.

It rained that afternoon, and she knows that's one of the signs he might appear. But she's taken her precautions. And she's not going to *not* go out. What are the odds?

As she crests the next low hill, she can see down the grassy slope ahead. The man on the ground at the creature's feet is clearly dead, a black wet patch spread around him on the moonlit grass. Crouching on its haunches in front of the man, the monster's knees extend far above its head. It reaches a long arm into the man's collapsing shape and plucks a rib from the carcass, sucks it clean with a slurping pop, and lobs it into a basket at its side.

The dog snarls and barks. The thing must hear them, but it gives no indication. She knows, hopes, *prays* that its aversion to the things that brought its death will keep it away. Should she have brought a whip? She takes the bag of chilies out of her pocket.

It peels the man's spine and skull from his husk and tosses them into the basket without savoring them. Her presence has hastened the pace of its harvest. It rises, arm stretching to retrieve the basket, cleaning the fingers of its other hand with its tongue. It turns toward her for the first time, touches the brim of its hat, and lopes off. It begins to whistle faintly as it goes.

Skunk ape

Enclosed please find some pictures I took in late September or early October of 2000. My husband says he thinks it is an orangutan. Is someone missing an orangutan? It is hard to judge from the photos how big the orangutan really is. . . . As soon as the flash went off for the second time it started moving. . . . It had an awful smell that lasted well after it left my yard.

———

BIGFOOT'S SUBTROPICAL COUSIN, the skunk ape is said to stand nearly eight feet tall and walk on its hind legs like a human. It's covered in dense fur and projects a horrifying stink, somewhere between skunk and rotting cheese. Most sightings occur in the woodsy, swampy Everglades region of Florida, but people say they've seen it in other areas around the state.

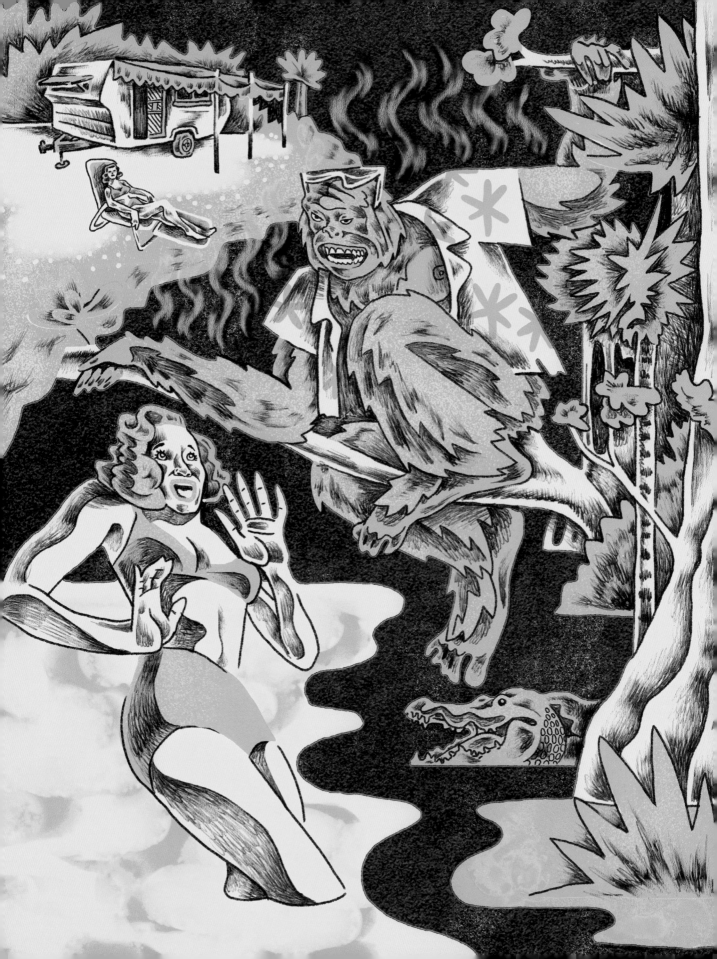

A 1957 encounter reported by a pair of hunters, who said a big, hairy, smelly man-thing came into their camp, stakes the ground for later sightings. There's a flurry of activity from 1971 to 1975, with tales of something that fits the description peering into people's windows and killing farm animals and pets. A pair of deputies shoot at an apelike thing that's following them. All of this is reported in the local media, and the legend of the skunk ape truly takes hold.

Enter Dave Shealy, founder of the Skunk Ape Research Headquarters, self-described world's expert on the creature. According to Shealy, he and his brother first saw the creature in 1974 while out hunting, and he's been fascinated by it ever since (he says he's seen it four times). He investigates local sightings, answers tourists' and the media's questions, and conducts lima bean–baited stakeouts to try to spot the creature again. In 2000, he released a video that he says shows a skunk ape moving across a clearing. According to an article in *Smithsonian* magazine, "[I]t's extremely hard to watch this video and see anything but a guy in a gorilla suit, hurrying across the swamp."

Other than eyewitness testimony, there are a few other videos and some blurry photographs, including two sent to local police in late 2000. In the accompanying letter, the anonymous sender claims to be a grandmother who has encountered what she and her husband think might be an escaped orangutan on their back deck. Whatever she photographed seems to look at the viewer from behind a palm frond, with glowing eyes and bared teeth.

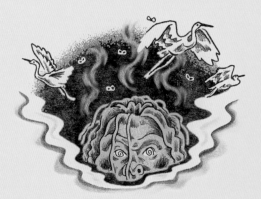

He's been crouching in this suit in the swamp for hours. He's switching between that and sitting on a log end to relieve whichever muscle is twanging. He's got the bottom of the mask rolled up to the bridge of his nose, which makes it easier to breathe, but it's giving him full flavor of the stink he rubbed into the suit's fur. The cracked raw eggs, Limburger cheese, and cooked-to-pulp cabbage concoction he'd left in the sun to cure was working like a charm, to his regret.

He wondered, though, if it had anything to do with the gators keeping their distance. Can alligators smell? He'd seen some ripples in the water now and then. He'd been here long enough to just about kill his phone battery playing games.

The flies sure seem to love the stink.

Sooner or later, some tourists would wander by. When they did, he'd emerge from his cover and dart across the clearing, back into the foliage before anyone got any ideas of catching him. They'd go to the news, testify to the stink, show them their phone photos, and he'd be secretly famous. He'd get one over on everyone. Only he'd know the truth.

His phone battery dies.

It's the stench that hits him first, cutting through his own terrible odor like a knife. He pulls down the lower part of his mask.

He's afraid to turn to look at what's rustling in the brush behind him, approaching. He feels a warm chuff of breath at his back, through the suit, leaving an oily film on his skin. Just stay still. He feels a kneading, a plucking by immense thumbs along his shoulder. The skunk ape begins to groom him for nits, at last having found another of its kind.

SLENDER MAN

In one of the two recovered photographs from the Stirling City Library blaze, he is in the shadows. In the other he is blurrily in the light. His shape is wrong. Do the teenagers see him? Why is he surrounded by children? Do they know each other? Why don't they run?

———

WE KNOW EXACTLY WHERE SLENDER MAN COMES FROM.

On June 10, 2009, a man using the screen name Victor Surge (real name Eric Knudsen) posted two black-and-white photos and captions to a paranormal photoshop challenge on the website Something Awful. In both images, there is a shadowy, very tall, humanlike figure (who has been added by Knudsen) looming over children or teens. In one it seems to be sprouting tentacles.

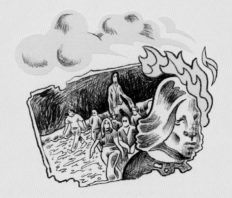

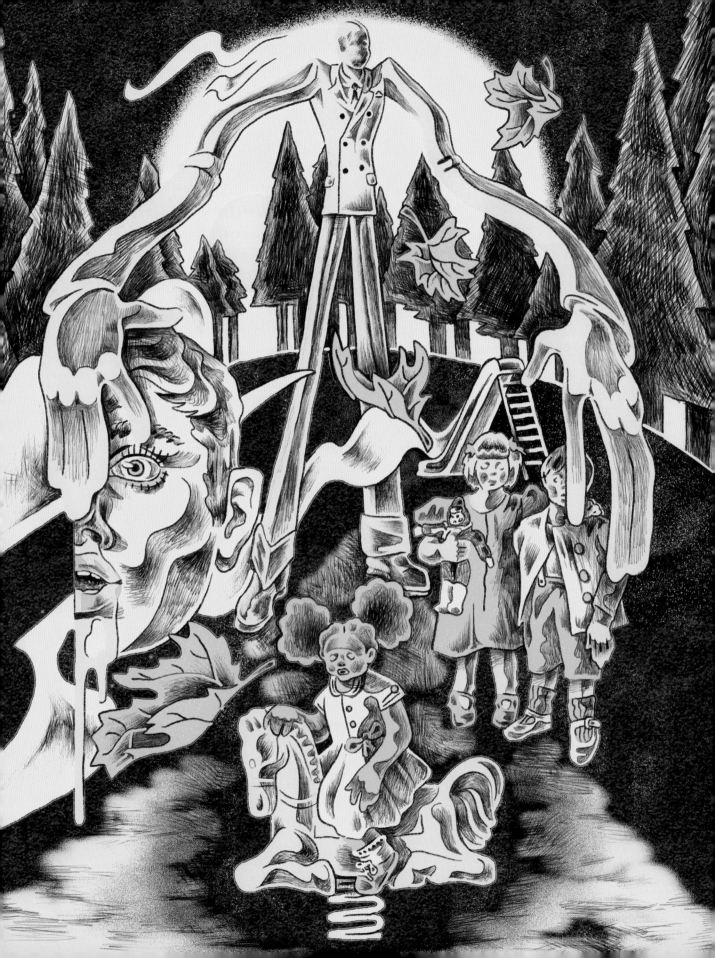

The short captions tantalizingly suggest a deeper story, with a purported witness statement about horrible comfort and killing, and references to missing and presumed-dead photographers, a fire, fourteen missing children, and "the Slender Man."

It is just enough to hook people, while leaving room for their own imaginations to run wild and try to fill in who the figure is or what he wants. Slender Man takes on a viral trajectory, and with no one person shaping the myth, practically anything is on the table. (Knudsen has said, "Because his motives are unknown. You don't know what he wants. What is he doing? Who knows? He's just a force, you know?")

Certain tropes emerge and are reinforced through repetition. Slender Man has no face. He's impossibly tall, with creepily elongated arms and legs. He's wearing a black suit. Sometimes there are tentacles. He has some interest in menacing, stalking, or befriending children and young adults.

Other characteristics accumulate over time, as citizens of the Internet churn out more stories, artwork, doctored photos, and videos, such as that proximity to him can cause nosebleeds, nausea, paranoia, and delusions.

Most people first heard of the figure through media coverage of a terrible true crime. In 2014, in Waukesha, Wisconsin, two preteen girls stabbed one of their friends nineteen times and left her in the woods to die (she survived). When asked why they did it, they said it was to somehow appease the Slender Man.

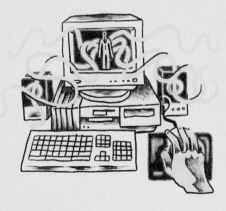

As a kid, he loved being scared. Just seeing the covers of his parents' books up on their high shelves was enough to terrify him. The screaming cat. The claw coming up from the sewer. He read them when he was too young, but it was fun. Fuel for what his parents call his overactive imagination.

He starts out by writing and posting creepy stories to various sites. He hopes kids are reading them, like he would have. But writing is hard. There's too much setup to get to the good stuff. It's much more satisfying to add something cool to a photo and just write a caption. *No one ever saw them again.*

He quickly realizes that he gets more traction with established monsters, who already have a fanbase. Everyone loves the Slender Man. At first, he grabs historical photos and sticks him in to stalk or befriend unsuspecting children. That's what everyone seems to want, and that's where the whole thing started. Play the hits. But it's too easy for people to find the undoctored photos, and ruin what he's spent so much time on.

He moves into taking his own photos, in the streets and yards and parks nearby, anywhere that he could have the Slender Man lurking, watching him. As he posts these, he notices that he gets more attention when he puts them up more frequently, documenting the Slender Man's escalating campaign to creep closer to his home and scare him to death.

The photos of the Slender Man inside his apartment are done in a sort of all-nighter haze. It's what he's been building up to. Bleary-eyed. Head aching. Adding the figure's nightmarishly long limbs, pallid no-face, and burst of tentacles at its back again and again, to menacing corners of darkened rooms, he's at last unsurprised when he doesn't need to add anything to the last photo he uploads. The shape is already there.

VAMPIR

Today the ninth victim dies. Each passes from hale to hollow overnight, and in a last dry breath says that he has visited them in their sleep. But he is dead, buried ten weeks ago. The villagers gather at the graveyard to pull his coffin from the winter earth. Lid pried off, there is a shock: He is fresh. They drive the stake into his chest and the body gasps, his mouth releasing a quantity of gore. Evidence of his post-death prowling, now brought to an end.

———

BEFORE THE NINETEENTH CENTURY, the bloodsucking, undead monsters of western European folklore were nothing like the elegant, secretly monstrous aristocrats that arose from gothic tales such as John Polidori's "The Vampyre" (1819), Sheridan Le Fanu's

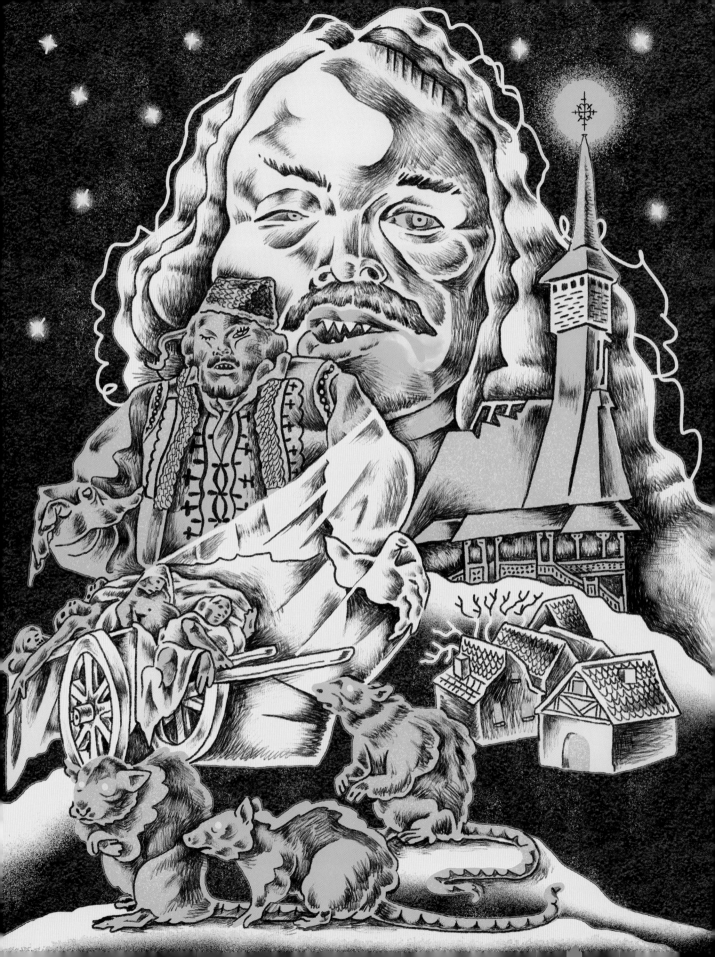

"Carmilla" (1872), and Bram Stoker's *Dracula* (1897). Instead, they were often associated with the plague, as those who fell victim to early infection were sometimes feared to be undead.

To end a suspected vampyr's curse, its body would have to be exhumed sometime after internment and staked through the heart. What the gravediggers found in these unearthed coffins confirmed their worst fears. The bodies may have seemed untouched by death (if they had been preserved by cold conditions), or to have withered horribly to reveal longer teeth and clawlike fingernails—the marks of the vampyr. The gases inside a corpse as it decays may sometimes expel rotten material that, if exuded through the corpse's mouth, may appear to be the blood of the living it has fed on.

Death brought by the plague was complex, terrifying, and poorly understood. But there are specific strategies that can be used against a vampyr. Wear garlic and rub it on or hang it around doorways, window frames, keyholes, and even livestock. At the time of death, bind the suspected vampyr's legs and fasten a sickle to its neck to keep it from roaming and force decapitation if it wakes up. Beware its attendant creatures and other forms: the rat and the bat.

How people were believed to become vampyres is a hodgepodge of folk superstitions (for instance, a cat jumps over your unburied body), but really anyone deemed a physical or social outcast could be accused of vampirism as much as they could of witchcraft and lycanthropy. The fancy, silk-caped, semi-respectable and aspirational castle ownership is all yet to come.

Unburied, in daylight it nests beneath the corpses of its family. The contagion that teems in its dead veins brings animation. Hunger. The corpse nest is warmed on its surface by the sun's rays, but it is cold underneath. Under what was its mother, father, wife, sons, it waits until dark.

It came for its own family first. Instinct. Like everyone else in the village, they had kept themselves inside, shut in to protect themselves from one type of death, only to fall victim to another.

In through the keyhole, it would come at night to feed on one, and then another, as they slept, drawing blood from their foreheads and hearts through its needlelike fangs. The bruises, swellings, and marks, the wasting away—it looked so much like the other death.

It has a sense of the time before its death and undeath. Swelling. Heat. Pain. Nothing. A new awareness, unblinking, on a corpse heap. Later a sense of seeing candlelight through the wooden shutters of its once home, waiting for it to be dark within.

Night by night now it follows the rats into other shuttered homes. Once-lit homes that are lit no more. The corpses are piled outside.

On this day, something shifts the bodies of its nest. There is daylight pain. It is tossed into a cart, and burrows under the truly dead. The cart wheels turn, and turn, and stop. Body weight accumulates above it. There is turning, and another stop. The weight lifts, and the light pain returns. It is tossed into a wooden box, but lands wrong. Not stiff enough.

This one.

The stake pierces its unbeating heart. The coffin lid is nailed shut. Now, finally, it will begin to rot, and feed the living organisms that eat the uncursed dead.

Werewolf

It's back. He can see it in the moonlight, the wolf that moves with a strange gait, first on four legs, then rising on its hind two. This morning he finds the barn doors open, the heavy crossbar on the ground, and six sheep now carcasses. He nails the barn doors shut tonight, and will nail shut his own.

———

OF ALL THE ANIMALS AROUND US, of course we would turn into wolves. In places where we coexist, humans and wolves have a long history of respect, fear, and kinship. We live in family groups and hunt and eat similar animals. Human hunters would sometimes wear wolf pelts to assume their spirit. From wolves, we have our canine best friends.

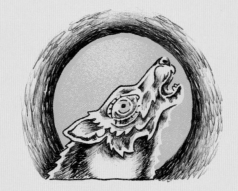

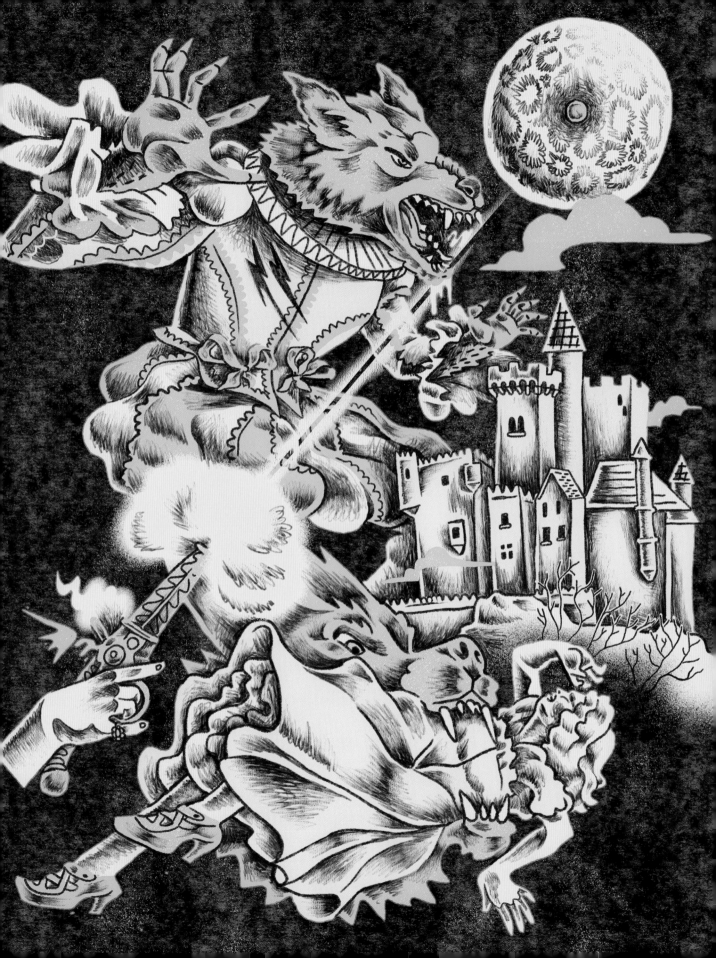

The narrative of humans being turned into wolves by divine intervention, generally as punishment, is ancient and cross-cultural. But the lore of the wolf-man, a monster who shifts shape back and forth, is more recent. Associated with witchcraft and witch hunts, werewolves were another form of demonically influenced human—in this case nearly always male—who could be accused of and made to confess to dark deeds through torture.

It was believed that in human form, werewolves would accept magic belts and/or demonic ointments that would allow them to become wolves when using them. There also develops a real psychological disorder diagnosis, called *lycanthropy*, in which the patient imagines himself as a ravenous wolf, and there are documented cases in which real murders associated their crimes with this folklore. In 1573, a French child murderer and cannibal named Gilles Garnier claimed he used an ointment to become a wolf. In 1590, German cannibal Peter Stumpp said he committed his crimes by the power of a demonic wolf girdle.

The idea that a full moon prompts transformation is popularized in the stories of the *loup-garou* (French werewolves). The insistence that a silver bullet should be used to kill a werewolf also comes from French lore, when, in 1767, a hunter used one to kill a beast that had been terrorizing the Gévaudan region of France. It was probably a hyena, and lead would've likely done just as well as silver.

Tonight's the night. He can feel it in his bones. He deserves this. The appointment should be his. He's from a good family. Good enough. He will not be passed over again. The old man will hear him out.

The ruffled collar is stiff. How do they wear these things? His costume tonight is nobility. The old man will see him as he sees himself, see things his way. He won't even have to pay the usual consideration, though he has saved for it. He has never felt more sure of himself. Confidence courses through his veins.

The grounds of the Moonlight Masquerade are cheerily lit. Roaming the halls and galleries, he looks for the old man. He has a few cognacs, having been offered, and is feeling warm when he sees the old man's masked but unmistakable soft shape, surrounded by partygoers. The old man's daughter is nearby. Maybe she, too, will see him in a different light.

As he approaches he breaks into a slick of sweat. He's not much of a drinker. Maybe that was a mistake. His temples are pounding. The long scratch at his thigh, from a fleeing beast in last week's hunt, is now unbearably hot. As he approaches, the old man is saying *the vineyard must* . . .

His vision pinholes. Losing his balance, he reaches out and grabs the old man's arm. He knows he shouldn't be touching him.

It happens in three breaths. His bones stretch and push outward as his skin retrieves them. His mask band snaps to reveal a gum-retreating snarl. His eyes roll back, then forward, and the color in his vision fades to blue and yellow— even as he forgets what those words mean. Every part of him bristles as fangs and claws erupt, an agony he voices with a howl.

One. Two. Three. He rips into the guests nearby, spreading a wet color that has a thick, warm scent he breathes in. A deep, wet breath. He can smell their fear. It's his last thought before the musket ball punches through his chest. He can see red again, and then sees nothing at all.

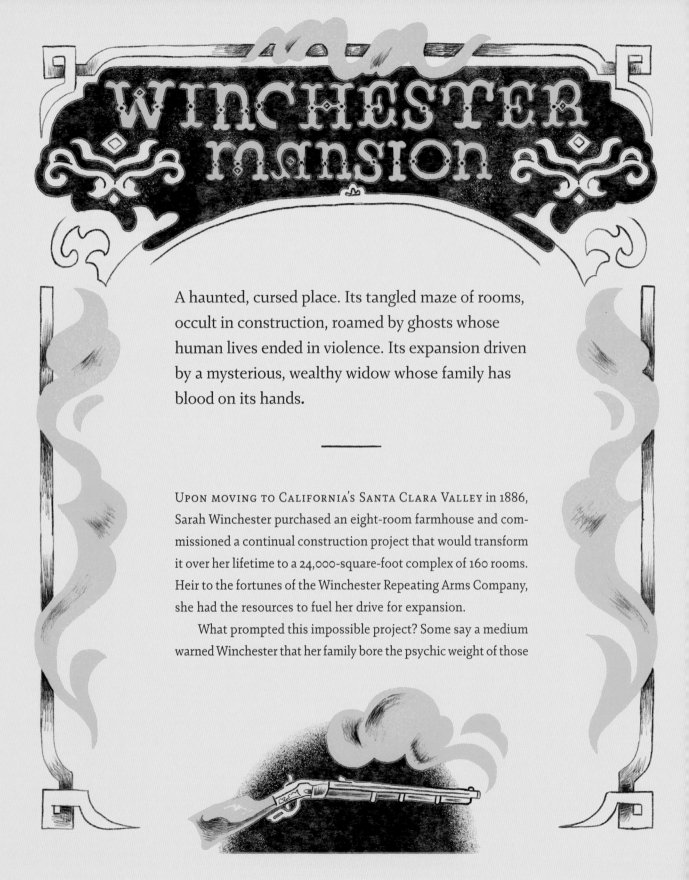

WINCHESTER MANSION

A haunted, cursed place. Its tangled maze of rooms, occult in construction, roamed by ghosts whose human lives ended in violence. Its expansion driven by a mysterious, wealthy widow whose family has blood on its hands.

———

Upon moving to California's Santa Clara Valley in 1886, Sarah Winchester purchased an eight-room farmhouse and commissioned a continual construction project that would transform it over her lifetime to a 24,000-square-foot complex of 160 rooms. Heir to the fortunes of the Winchester Repeating Arms Company, she had the resources to fuel her drive for expansion.

What prompted this impossible project? Some say a medium warned Winchester that her family bore the psychic weight of those

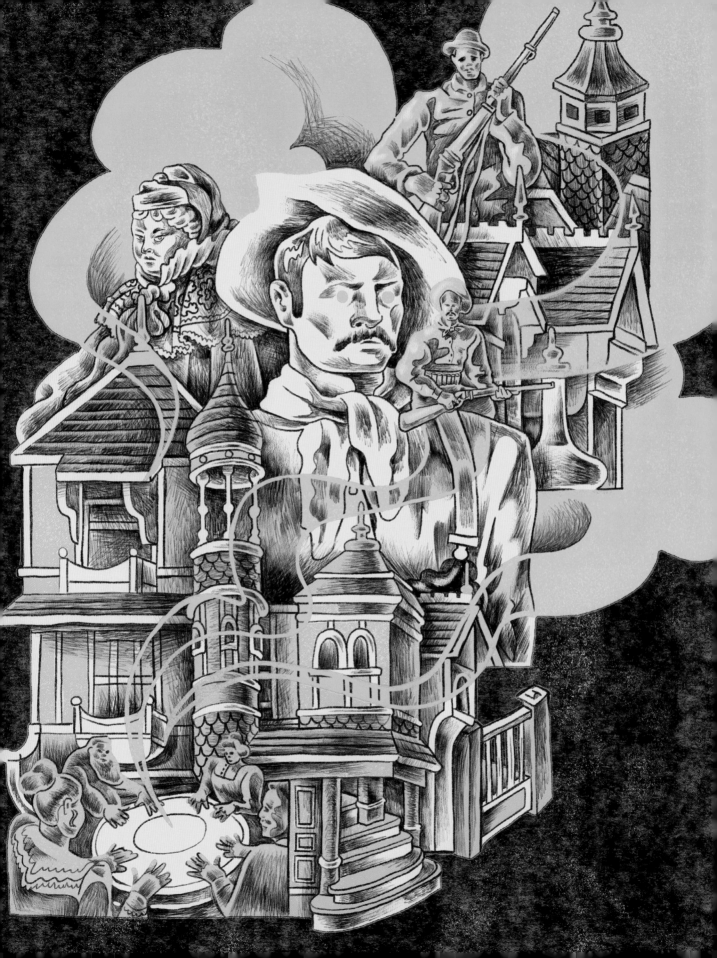

killed by her family's firearms, and that she must build a house to keep their spirits. In another version, Winchester believes she will live forever, as long as the house's construction is also endless, and the ghosts get lost in its labyrinthine turns. (Winchester biographer Mary Jo Ignoffo sheds doubt on all of this. See Further Reading, Listening, and Viewing.)

Either scenario would provide an explanation for the manic building project and its inexplicable features, which include doors that lead to nowhere or open onto fifteen-foot drops, and a pointless staircase leading into the ceiling. But it's also tempting to interpret the mansion as a non-metaphysical place of sadness, which Winchester created upon moving West after her husband died of tuberculosis. (The second tragedy in her life, after the death of their infant daughter early in their marriage.)

That Winchester lived mostly as a recluse on the mansion grounds until later in life would only fuel the early dark rumors and mystery surrounding the place.

I t was easy enough to sneak into the widow's place. It's too big for anyone to mind it all. Other than the widow, there are a few shapes moving behind the windows.

It was easy to accept the dare. Once inside, he would look for something to bring back to prove he'd gotten in. Maybe a glass paperweight. The one on his father's desk at home holds a spider. Maybe he'd find a rifle.

His eyes adjust in the moonlit dark as he approaches the house. Picking a low window on a far side, he jimmies it open with his pocketknife, slides the window up, and slips over the sill. When the window slides closed, the air inside the house seems to thicken. He is in some kind of living room. Couches. Fireplace. Boards creak under his feet as he peers into rooms along the hall, keeping to the edge of the house and using the moonlight.

Another sitting room.

A room full of books.

He's holding out for a study with a desk.

In the next room it takes a moment for him to register the shape of a person, in a chair, in the corner.

Oh. He didn't mean to say this aloud.

The figure rises. It is a man in uniform.

I didn't mean . . . He stops talking.

The figure is covered in dust, floating just above its surfaces. As it approaches, the moonlight illuminates the man's face—what remains of it.

We're not here for you. He feels this rather than hears it.

We're here for her.

Go.

WINDIGO

In its once-human form it moves tall among the pines, its body horribly long and gaunt, its dull skin stretched on hungry bones. It stinks of rotting death. The feasts of human flesh do nothing to fill it, adding height but not mass. It will always want more.

Originating in the folklore of Algonquian-speaking First Nations, the windigo (or wendigo, among its many names) is a terrifying figure that is both a physical creature and a possessing spirit, born of circumstances of harsh cold, hunger, scarcity, and death.

Embodied, it's a man transformed into a monster through cannibalism: fifteen-feet tall, nearly skeletal, its lips and cheeks

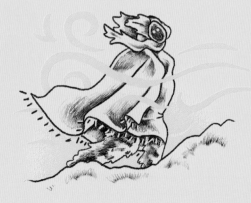

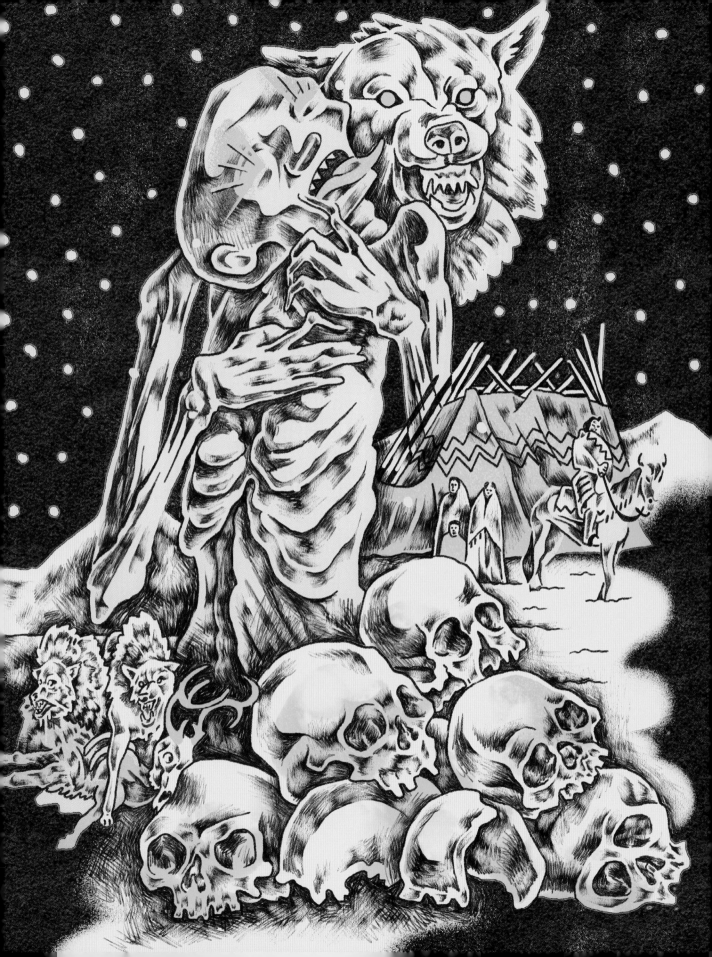

chewed to bare fangs. Sometimes it has antlers branching from its head. It moves as swiftly as a wolf over snow, or may hover above it. By some accounts, it will shift shapes to those of the animals or humans it has eaten. Family members hear long-lost kin call out from distant snow, only to be lured and devoured.

A malevolent spirit, the windigo will possess humans who are socially isolated, susceptible to greed, or subject to extreme conditions such as hunger or cold in natural or more violent colonial circumstances, and push them into cannibalism.

In a terrible and well-documented case in Alberta, Canada, following the harsh winter of 1878–1879, a man named Swift Runner emerges from his winter camp and announces to Catholic missionaries that his family have all starved to death. He seems surprisingly well fed. When Canadian mounted police visit the camp to check on his story, they find a horror of bones, some broken and visibly chewed, along with human skulls and kettles of fat. Swift Runner says that a windigo spirit had told him to eat his family, and after resisting for a time, he did, killing and devouring his wife, six children, brother, and mother-in-law. He was executed by hanging later that year.

Settling this far north had been a terrible idea. His vision—of their self-sufficiency, his capability, their forging this life together—had been persuasive, until it wasn't, and made her feel safe, until it didn't. The warm months passed without notice, by days and weeks. These freezing months crawl with every bitter second.

She has never been so cold, so hungry, so sleepless. Her thoughts are strange.

They've been eating pine from the insides of the trees, from beneath the bark. Hacking it out with the axe blade. This seems strange. But it is one of the things he knows, about survival, one of his many confidences that she's come to think of as his tricks.

Step, by step, by step, by step. They wander the snow, looking for movement. For something moving that they can eat. She feels dizzy.

The only thing moving in the snow is her husband. Walking ahead. Step, by step, by step.

She wonders what it would be like to chew the inside of the bones in his leg. Past the flesh, past the meat, straight to his core. Would it be stringy, like the pine pulp?

Every cell in her body is hungry. Would always be hungry now. It's all she can do to step through the snow until they approach the cabin, promising the hunger: *soon*. She will need the axe.

He makes his way toward her through the marketplace crowd, in the village he has returned to, after all that has happened. She doesn't notice him at first, a strange, ashen man in his sixties. *Angelina*, he says, *Angelina, it's me*. She looks at him, at his face. *No*, she says. *No, brother*, she says. *We buried you. Long ago.*

———

MUCH DIFFERENT FROM THE CONCEPT of the undead, flesh-eating zombie, the Haitian zombi is a figure of specific terror, rooted in the horrors of slavery. The fear is not that you will be menaced by these tragic creatures, who are not usually a threat to others, but that you will become one yourself.

Under French colonial rule, the part of the Caribbean island of Hispaniola that's now known as Haiti was a place of

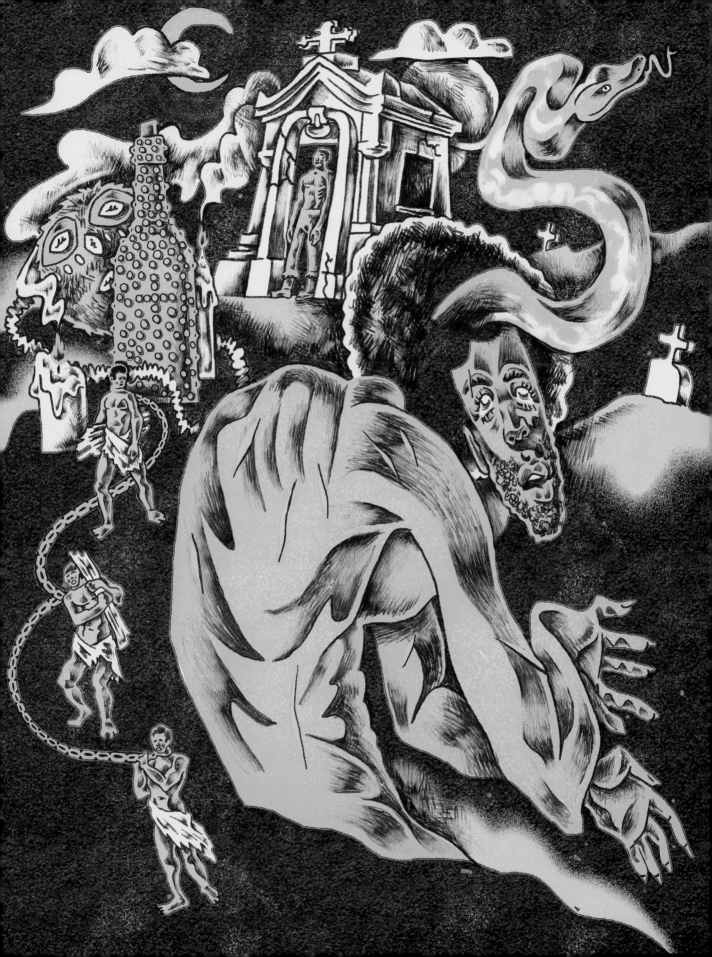

international trade and mass enslavement on sugar, tobacco, and coffee plantations. Enslaved people from West Africa brought with them a belief that our physical bodies are driven by two spiritual aspects—one of conscious will, the other of motile operation—and that in the time between death and the soul's passage, evil actors may separate the two. Slave traders exploited this belief, claiming that a person who takes their own life in this existence will not escape slavery, but rather be damned to it forever, with their spiritual free will stripped.

Over time, zombi folklore expanded to include the beliefs that the zombi state can be created through sorcery, that a person can be made to seem dead and then brought back, or that a dead person can be made to rise, in each case with their free spirit controlled and held inside a bottle. The captured spirit can be put to work, as can the mindless physical body. This is accomplished through the use of toxic potions.

The most famous case of purported zombification is that of Clairvius Narcisse, a Haitian man who died (everyone agrees) and was buried in 1962. In 1980, a man who said he is Clairvius approached his sister and identified himself using a family nickname. He later answered questions that seemingly only the real Clairvius would know. In his telling, his brother had sold him to a *bokor* (a sorcerer), who simulated his death through poisoning, exhumed him, and kept him numbed and working alongside other zombis by administering a mind-controlling potion.

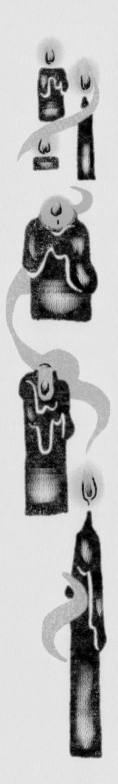

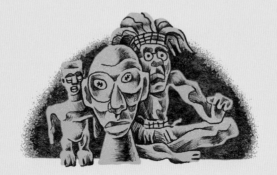

He remembers his family crying over him. He remembers the doctors shutting off the machines that sound a loud, flat tone meaning there is nothing more to be done. He does not see himself from above, as a rising spirit. He sees through his own eyes, until a doctor moves past his weeping sister and uses his gloved fingers to shut them.

He hears crying. Voices in the hallway. Bed wheels turning. Doors opening, closing, opening. More voices, a fuzzed murmur. Then nothing, a fading feeling of remembered sleep.

He hears and feels the coffin lid being nailed shut. Awareness spreads. His skin is on fire, crawling with insects. *The insects can't be here yet. Can they?* His awareness fades out.

Then the sound of wood ripping. He senses light through his eyelids. He hears a puffing sound and a fine dust settles onto his face. His eyes open.

The tall man is feeding him a salve. It's different from the potion the tall man had slipped into his drink, right before his body started shutting down, before the hospital and then the coffin.

The tall man is telling him the story of the rest of his life. He belongs to the tall man. He will work for the tall man. He is no one. No one will look for him. There is nothing else. He sleeps.

He awakens before he's supposed to. It's dark. There is a fog of unfeeling in his mind that he recognizes as the intended effect of the paste. It's something he notices. What else can he notice? He imagines himself, and sees himself as a distortion, a dim reflection in dull metal. But there is a thin, bright edge. A clear point. Something he can expand, polish, to reveal more of himself. This will be his work, his true work. He will tell his own story.

FURTHER READING, LISTENING, AND VIEWING

BOOKS AND ZINES

Captive of the Labyrinth: Sarah L. Winchester, Heiress to the Rifle Fortune, Revised and Updated Edition by Mary Jo Ignoffo

(Columbia, MO: University of Missouri Press, 2022)

An involving and detailed biography of Winchester, with (alas) plausible and sensible explanations for the mansion's architectural mysteries.

The Cinéaste's Guide to Chupacabras on Film by Damon Charles Bishop

(Stone Ridge, NY: Hambone Industries Press, 2021)

An entertaining zine in which the author watches, rates, reviews, enjoys, or suffers through every chupacabra movie he can find.

In Search of Dracula: The History of Dracula and Vampires, Completely Revised by Raymond T. McNally & Radu Florescu

(New York, NY: Houghton Mifflin, 1994)

The authors carefully map facts to fiction in this historical and cultural investigation of Vlad the Impaler, Bram Stoker's *Dracula*, and European vampire folklore.

Krampus: The Devil of Christmas by Monte Beauchamp

(San Francisco, CA: Last Gasp, 2010)

An irresistible collection of holiday Krampus postcard imagery, sent throughout Europe from 1898 to 1914.

Never Whistle at Night: An Indigenous Dark Fiction Anthology edited by Shane Hawk and Theodore C. Van Alst Jr.

(New York, NY: Vintage Books, 2023)

A scary, fun, and illuminating collection of horror stories and a discovery engine for finding new favorite authors from among the twenty-six contributors. Noted especially for the Windigo story "Hunger" by Phoenix Boudreau.

Ponti: A Novel by Sharlene Teo

(New York, NY: Simon & Schuster, 2018)

A novel following the lives of three Singaporean women in which a key element of the story is the narrator's mother having starred as a pontianak in a (fictional) late-1970s B-movie called *Ponti!*

Tracking the Chupacabra: The Vampire Beast in Fact, Fiction, and Folklore by Benjamin Radford

(Albuquerque, NM: University of New Mexico Press, 2011)

By a managing editor for *Skeptical Inquirer*, a five-year, chase-every-lead investigation that is also in its aggregate detail a fascinating account of how folklore takes its shape and hold.

Tracking the Man-Beasts: Sasquatch, Vampires, Zombies, and More by Joe Nickell

(Amherst, NY: Prometheus Books, 2011)

Critical, research-illuminated takes on the Mothman, chupacabras, werewolves, vampires, Haitian zombis, and more.

UFO: The Inside Story of the U.S. Government's Search of Alien Life Here—and Out There by Garrett M. Graff

(New York, NY: Simon & Schuster, 2023)

A lively, fact-focused deep dive into the real phenomenon of unidentified flying objects in the context of recent declassifications and historical records.

Unquiet Spirits: Essays by Asian Women in Horror, edited by Lee Murray and Angela Yuriko Smith

(Anchorage, AK: Black Spot Books, 2023)

A strong and often personally rooted collection of essays. Related to *Eerie Legends*, I recommend "The Demon Haunted Girl: The Power of the Pontianak Myth in a Patriarchal World" by Christina Sng.

Yokai Attack! The Japanese Monster Survival Guide by Matt Alt and Hiroko Yoda with illustrations by Tatsuya Morino

(Tokyo: Kodansha International, 2008)

A well-researched, accessible, pop-culture-paced guide to dozens of Japanese folk monsters, including tips for surviving and avoiding an encounter, and featuring the Nure-Onna.

Yurei Attack! The Japanese Ghost Survival Guide by Matt Alt and Hiroko Yoda with illustrations by Shinkichi

(North Clarendon, VT: Tuttle Publishing, 2012)

Just as fun and informative as *Yokai Attack!*, this volume focuses

142

on ghosts and includes a chapter profiling seven very different, very angry onryō.

MOVIES

Häxan, 1922, directed by Benjamin Christensen
An imaginative document of European associations with the Devil and witchcraft, which informs the folklore around werewolves and vampyres.

Ju-on: The Grudge, 2002, directed by Takashi Shimizu
More than twenty years on, this vengeful spirit film is unshakingly creepy, with its directly simple effects reading like verité. Plus, cat boy.

Ringu, 1998, directed by Hideo Nakata
With *Ju-on*, the movie that sparked an international boom of attention for Japanese horror films, particularly haunted by onryō.

Vampyr, 1932, directed by Carl Theodor Dreyer
Full of eerie images accomplished through early film tricks such as double exposures and reverse motion, a nightmare vision of a family and a village stalked by a European vampyr who is as much a curse as a monster.

ONLINE DOCUMENTS

"Aboard a Flying Saucer: The Adventures of Two 'Kidnapped' Humans" by John G. Fuller, *Look* magazine, October 18, 1966, as found on cia.gov

https://www.cia.gov /readingroom/docs/CIA-RDP81R00560R000100010003-8.pdf
A surprisingly in-depth article on the Betty and Barney Hill abduction with many quotations directly from them, including under hypnosis. Interesting enough that the CIA has bookmarked it.

Government of Mexico Tourism Webpage for La Isla de las Muñecas from April 17, 2001, accessed via the Internet Archive
https://web.archive.org /web/20110722225234/http://www .xochimilco.df.gob.mx /turismo/isladelasmunecas.html
A personal recollection by Professor Sebastían Flores Farfán, director of the Xochimilco Historical Archives, who knew Don Julian Santana Barrera, the creator of La Isla de las Muñecas.

Skunk Ape "Suspicious Incident" Police Report from January 18, 2001, contributed by Shelby Webb, *Sarasota Herald-Tribune*
https://www.documentcloud .org/documents/1264101-skunk-ape-police-report
The police report, complete with photographs, filed by an anonymous citizen having encountered, possibly, a skunk ape.

BLOGS & PODCASTS

"Beware the Witch-Owl, La Lechuza," *Latino USA*, October 30, 2015
https://www.npr.org /2015/10/30/453213510 /beware-the-witch-owl-la-lechuza
An informative and entertaining episode that digs into the creature's origins, including a first-hand account of facing the witch and growing up around its folklore.

"La Llorona: An Introduction to the Weeping Woman," *Folklife Today*, October 13, 2021
https://blogs.loc.gov /folklife/2021/10/la-llorona-an-introduction-to-the-weeping-woman/
A Library of Congress American Folklore Center post that excerpts some accounts of La Llorona from its collection and includes more recent and personal reflections and stories by the center's staff and associates.

Susto, 2019 to present, created and hosted by Ayden Castellanos
https://www.sustopodcast.com
Brief recountings of eerie legends of Latinx and Hispanic cultures, accompanied by research, commentary, and personal anecdotes about encountering the folklore (the show's creator was born and raised in the Rio Grande Valley on the Texas-Mexico border), with episodes on El Silbón, La Islas de las Muñecas, La Pisaderia, chupacabras, and more.

WEB SERIES

Monstrum, 2018 to present, written and hosted by Dr. Emily Zarka
https://www.pbs.org/show /monstrum
A PBS Digital Studio series readily available online, each narrated and animated episode brings additional historical, literary, and cross-cultural context to many of the eerie legends in this book.